BOOKS BY GIANFRANCO BARUCHELLO

Mi viene in mente
La quindicesima riga
Avventure nell'armadio di Plexiglass
Come ho dipinto certi miei quadri
Alphabets d'Eros (with Gilbert Lascault)
Il montaggio
Fragments of a Possible Apocalypse (with H.M.)
Sentito vivere
Marcel Duchamp in 20 photos
La stazione del Conte Goluchowsky
L'altra Casa
Agricola Cornelia S.p.A.
La scomparsa di Amanda Silvers
How to Imagine (with H.M.)

BOOKS BY HENRY MARTIN

Arman
Adami
Renato Mambor's EVIDENZIATORE
Fragments of a Possible Apocalypse (with G.B.)
An Introduction to George Brecht's Book of the Tumbler on Fire
"01/80" Notes on the Work of Teodosio Magnoni
FAVORISCA: On the Work of Gianfranco Baruchello
How to Imagine (with G.B.)

WHY
DUCHAMP

an essay on aesthetic impact

Gianfranco Baruchello

& Henry Martin

DOCUMENTEXT

McPHERSON & COMPANY

All rights reserved. For information, address the publisher, McPherson & Company, P. O. Box 638, New Paltz, New York 12561. Publication of this book has been assisted by grants from the New York State Council on the Arts and the National Endowment for the Arts, a federal agency. Manufactured in the United States of America. Design by Bruce R. McPherson. First edition.

Library of Congress Cataloging in Publication Data
Baruchello, Gianfranco.
 Why Duchamp.
 "Documentext."
 Bibliography: p.
 1. Duchamp, Marcel, 1887-1968—Criticism and interpre-
tation. 2. Duchamp, Marcel, 1887-1968—Influence.
I. Martin, Henry, 1942- II. Title.
N6853.D8B38 1985 709'.2'4 85-11544
ISBN 0-914232-71-1
ISBN 0-914232-73-8 (pbk.)
ISBN 0-914232-72-X (lim. ed.)

PREFACE

On completing the manuscript for *How to Imagine* (published by
Documentext in 1984) I suggested to my co-author, Gianfranco
Baruchello, that our discussion of his attempt to see the running
of a farm as a work of art had led us to the threshold of still
another and surely no less peregrine adventure. Marcel Du-
champ had become a part of *How to Imagine* to a degree that
neither of us had planned or been able to foresee, and I had
come to feel that we might have something to gain by making
him the subject of a separate investigation. Both of us were
accustomed to seeing him as a more or less constant point of
reference, both of us admitted to finding him often confusing,
in spite of everything we might be said to 'know' about him, and
both of us were convinced that our confusion was more an asset
than a liability. Baruchello, moreover, could talk about the
meanders through which his attention to Duchamp had become
a part of his own activities as an artist; he was ready to engage
himself with my own supposition that some of the apparently
arbitrary ways in which artists relate to the work of their pred-
ecessors can be an example from which the rest of us might have
something to learn. Whereas critics are obsessed with 'under-
standing' art, artists sometimes have a gift for absorbing it and
for using it arcanely as a source of personal energy.

One of the *leitmotivs* of this book is the search for a title. We
knew what we wanted to do, but our efforts didn't have the
comfort of belonging to any readily definable literary form.
Why Duchamp is as good a title as any, but perhaps no better than
some of the others. We toyed with titles as though looking for a
question to which our book would then be an answer. Criticism
and art history normally ask quite different kinds of questions
that can be both formulated and answered with an appearance
of far greater clarity and directness. We've imagined, though,
that the forms of human exchange that take place through art
are not really distinguished by their clarity. Art is an entirely

mysterious way in which some people sometimes manage to find themselves in much the same place at much the same time, which is a definition less of communication than of communion. An exact description of the problem sounds disconcertingly large, but we are trying to refine our awareness of the modes of real inter-relationship through which one human being can have meaning for another.

Baruchello's personal reminiscences about the privilege of having been intimately acquainted with Duchamp are a natural part of this book, but it isn't at all our purpose to explore them, as though searching for new and revealing biographical data. 'Objective' biographies are one of the conventional tools of understanding that we've had the presumption to call into question. We're not interested in finding a 'key'—whether historical, or critical, or biographical—to the work of Marcel Duchamp since we're convinced that the truth of an artist's work is something that all serious viewers have to create, rather than simply to decide upon, for themselves. Marcel Duchamp would have been the first to concur with such an assertion, and this is part of what makes him so attractive for us. The truth and importance of the work of an artist lie in the truth and importance of what it permits you to do—in the thoughts it helps you to think and in the actions it helps you to perform. It follows, moreover, that the quality of a work of art lies in the quality of your reaction to it, which both begs the question and gives it personal urgency. If your response is to be worthwhile or edifying, it has to give expression to the depth of your individuality. There is a sense, then, in which Baruchello's reactions to Duchamp don't necessarily represent my own. We agreed that he would speak as an artist, and thus as a voice to which we imputed a special privilege, and my own design was simply to listen to him, aiding and abetting him as best I could. To recognize myself in his arguments would be as much beside the point as to feel a need to refute them. The art critic, if he is anything, is a specialized spectator, which is to say that he has a special interest in the

condition of spectatorship. Here I have pushed that interest to the limit of trying to observe another spectator as he goes through his paces.

This book, like its predecessor, *How to Imagine*, began as a series of conversations. In Rome, in Baruchello's studio, we talked nearly every morning for all of April and most of May in 1981, and recorded nearly one hundred hours of discussion. My work, in the course of the next two years, was to pull this material into the shape that it most clearly seemed to imply.

HENRY MARTIN

WHY
DUCHAMP

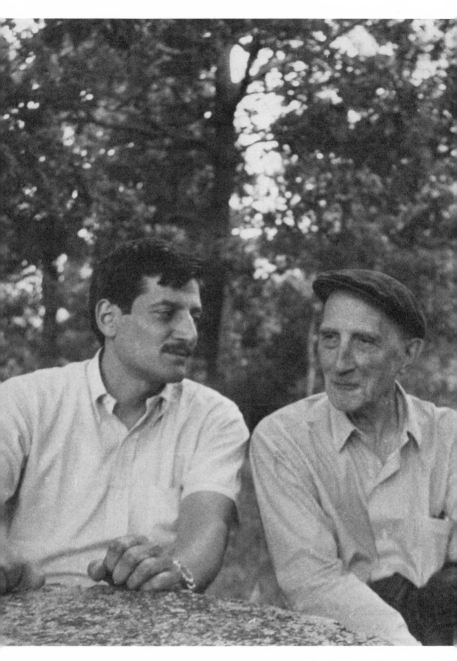

Baruchello and Duchamp, circa 1963.

This last time my wife and I were in Paris, we went out to pay a visit to Teeny Duchamp. It amounted to quite a good while since we'd been in touch with her, but she wasn't really surprised when we phoned, and she was curious to know what we'd been up to. So once again I found myself telling the story of Agricola Cornelia, and she was much intrigued by the way my thoughts in running an agricultural enterprise as an art experience had revolved so much about Marcel. I found that very gratifying. She was really cordial and we set up an appointment to go and see her out in the country where she lives in one of those fine old French farm houses that are so oddly but so perfectly placed, smack in the middle of a village. The street runs right in front of it, but then you go through a big wooden door and enter a patio with great handsome trees around it. The house itself is only the first of three or four buildings that connect to form an almost squarish courtyard with a wing for guests on one side and greenhouses on the other, and at the back there's still another wing that serves as a living room. And out beyond that, there's a garden surrounded by an ancient wall, covered with raspberry vines. It's all very beautiful, all very green and dotted with white garden furniture, and this is where Teeny met us and offered us something to drink. She has a Moroccan couple that works for her, a man and his wife, both of whom are very curious, like characters out of the tales of Scheherezade. Teeny asked them to bring out a bottle of champagne that had earlier been put in the freezer.

What was so nice about this visit was that Teeny's attitude to Marcel was exactly what you'd want it to be. George was there too, he's the grandson of Pierre Matisse, which is to say that he's the son of Teeny's son Paul, and he

was mainly concerned with talking about technological problems that you'd hardly think of as Duchampian at all. Conversation could shift and flutter any way it wanted to, and there was nothing of that triumphant air of the widow of the late great painter whose place and reputation always have to be defended and whose life and work are the only possible subject of discussion. The way Teeny lives has nothing to do with any of that. She doesn't have any axes to grind, no interpretations that she wants or feels it her duty to promote, and she very much has a life of her own. Everything was comfortable and relaxed, and we were just a group of people sitting in a garden drinking champagne under two enormous shade trees. And as though to make the garden perfect, there was also a big pink parrot that Teeny had been given by a friend. Not a parrot really, but a big Australian bird with an enormous beak and an incredibly exquisite color, a kind of clear peach-colored pink.

Afterwards, as it started to cool, we went into the house and sat and talked some more, and while we were talking I could look back behind her to the wall and the little chess table that Marcel had always had, and all of the pieces were set up on it. It's the table he'd always had in his studio on 10th Street in New York. There was also a copy of the *Bicycle Wheel* from the edition he did in the 1960s, it stands in front of a long white mantle-piece that's above the fireplace. But the very first thing you see when you enter the house is the original version of the *Cemetary of Uniforms and Liveries*. It's the study he did before doing that section of the *Glass*. It's in a great big heavy frame cemented into the wall, and of course it's broken like all of the things he did on glass; every last one of them has been cracked, except maybe for the *Glider*. And it's all full of

lead, its whole air is leaden and the colors are going off towards black, you already have the feeling of standing in front of something that was dug up by an archaeologist. It struck me very much that this thing is already so ancient.

So that was the atmosphere and we talked about Marcel, and we talked about what Marcel had meant for me. I left her a copy of the little book I did called *Agricola Cornelia, S.p.A.*, and I also gave her the manuscript of *How to Imagine* since so much was said there about Marcel, especially towards the end. The whole idea of using Duchamp as part of the justification for running a farm as a work of art was an idea to which Teeny responded very well, and she even reminded me that one of Duchamp's descriptions of his Bride was to call her an 'agricultural machine.' I also told her that you'd suggested that we do a sequel to *How to Imagine*, not really a sequel, but a book dedicated entirely to Marcel from the point of view of a person who has had a very intimate and unorthodox way of making use of him. A book that might be entitled *A quoi sert Marcel Duchamp?*, with the idea of asking that question in much the same way that you might ask it about a glass and be told that it's for drinking water. Or like that phrase you used to see in automobile ads in America: 'ask the man who owns one,' even though quite precisely what I own is something that remains to be seen. This also led to talking about the other books that have been written about Duchamp. I asked, for example, if she'd seen any of the writing that's been done in Italy where Schwarz's vision of an alchemical Duchamp has been carried even to the extreme of maintaining that he was consciously and intentionally a part of an alchemical tradition; but this, in fact, was the first she'd even heard about this stuff, and she confirmed my suspicion that

alchemy was something that Marcel couldn't have cared less about. There's an interview where he said that if he'd ever been an alchemist it was *sans le savoir*, since that's the only way it would be possible to be an alchemist today, and Teeny is quite certain that he said what he meant to say and that *sans le savoir* was quite ordinary French for 'without being aware of it.' People have been so perverse as to try to turn that phrase inside out by saying that *le savoir* means 'the hidden knowledge' and that modern alchemy is alchemy *sans le savoir*, whereas medieval alchemy was *avec le savoir*, but that's just a load of bullshit. Maybe Marcel had once been at a cocktail party and quipped that he was an 'adept' like an alchemical adept, but that's something anybody could say, I say things like that myself. Surely he'd never gone any deeper into it than that. She had, though, seen Lyotard's book, *Les Transformateurs Duchamp*, and she found it extremely intelligent. She also has a great deal of respect for the *catalogue raisonné* of the Schwarz book even though she's critical of much of the rest of it, but that's no news; you find the same thing in the acknowledgements in the Paul Matisse edition of Marcel's new *Notes*, which isn't however to say that Teeny and Paul are in agreement about everything. She wasn't really explicit, but I still got the idea that there were any number of things about that book too that she might have handled differently. Maybe she'd have made it less *de luxe*, less pompous, maybe she'd have wanted to print more than a thousand copies of it. I couldn't quite tell. Even though she has her own ideas and expresses them, she's not at all polemical about the things that other people say and do. That was Marcel's attitude too. She remembers how he'd always say, 'Let the little birds make pee-pee.' He'd made very much a point of keeping their lives uncomplicated, and she says that this is

what people don't realize about Duchamp: that he was a person of enormous simplicity, and that that was how he lived. So even if all the things he did and said have made a tremendous difference to a tremendous number of people, that influence wasn't the result of any activism on his part. That's the magic of his work. People think he was so art-world conscious of himself, I've sometimes made the mistake of thinking that too, but whatever he was involved with can't really be thought of as simple self-promotion. Thinking those kind of things is a way of avoiding the impact of something much more subtle. He had an entirely natural charisma, and he made no attempt to make use of it, but it was there all the same and it always kept on growing more powerful. His gestures, his words, his way of putting images together were a way, finally, of calling a halt to so much idiocy. There was no way he could actually eliminate all of this stuff that's back again with us now, but only for a moment—all of this expressionism and capitalist realism—and there will always be room for *impasto* and all the rest of it, but he did create an alternative: the alternative of a kind of painting that can serve as a mainspring for philosophy. That's what's so new about him. Picasso, for example, is entirely different. Picasso's important in terms of your political consciousness of the world, but he doesn't lead you into philosophy, or at least not very far. You can be happy that he made a painting about the bombing of a Spanish village by the Luftwaffe, but he's not one of those painters who make you think. He's not Kandinsky, or Klee, or Malevitch, he's not one of those painters who rank as one of the great *empêcheurs*, and that's how you have to define Marcel Duchamp, which is what made it so touching to hear his widow call him a man of enormous simplicity.

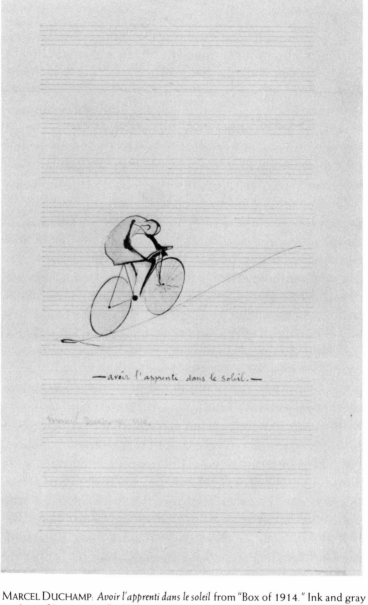

MARCEL DUCHAMP: *Avoir l'apprenti dans le soleil* from "Box of 1914." Ink and gray wash; 10⅝ × 6 11/16″. Philadelphia Museum of Art: Louise and Walter Arensberg Collection.

How was it then that I first met this person? Essentially it all started with Matta and one of his typical acts of conversational terrorism. He gave me the same kind of treatment that I myself might give today to someone who was just beginning to paint and who also felt the importance of a certain kind of intellectual background. It's not at all as though I'd begun to do little landscapes because I was developing a nervous tick or felt myself on the verge of a breakdown and needed something to help me stay calm. I was much farther gone than that. Rather than my nerves, it was my whole life that was breaking down, and at the time I first met Matta, the entirety of my existence was virtually in a state of collapse. I'd lost all possible reason to look at the life I was living with any kind of feeling of enjoyment. All the things I'd been doing before were in need of being replaced and painting was what had started to replace them. It was the only thing that seemed like a natural alternative, and I'd slipped into painting with something of an entirely natural ease. I'd always been interested in art, and interested too in painters, so lots of my friends were painters. I'd always gone to the Biennale and I saw all the shows, and it was also a part of the things I was reading, the books by Klee, the course he did at the Bauhaus, and, well, it all came out naturally, and I was doing all the things that everybody was doing then. There was a phase of going through all of abstract expressionism, making blots and traces, imitations of Burri, enormous masses of the stuff, and later of course I burned it all, but it was always clear that doing it had been absolutely right. It was all a part of a great liberation, and this was the period when I first met Matta. It must have been Pietro Cascella who introduced me to him. Matta then was a very interesting person and a real charmer, and he's still a real charmer,

but then even more so. And he sort of liked me and seemed to have decided that there was some way he wanted to help me, which he did. Once he came to the house to see the things I was doing, and that was a period when I was making telephones split in half and pasted down. It was at the end of the 1950s. There were also little drawings of the telephones, as though they were characters in some sort of story; they more or less looked like heads, but they weren't precise and alphabetical like the things I do now, like the things that really began around 1962. I remember that he took all of the various individual things that I had shown him and he stacked them up together against a wall and said that each of them alone was a little too secretarial, more or less as though they were letters that I'd dictated, and that the painting I should really be doing was all of them put together. And then every time we saw each other he'd have something new to say. He really enjoyed help-ing me.

He also tried to get me interested in some of the techniques of the Surrealists. He'd say that I ought to make blotches on the backgrounds of my paintings and look for images inside of them, or that I ought to make the kind of rubbings that he calls *frottages*. When he wasn't talking about the kinds of things that had been done by Max Ernst, he was giving me something of a course in Matta-ology. It was all a long explanation of Surrealism, he'd say Surrealism was this, Surrealism was that, Surrealism is where you've got neither top nor bottom, no left or right, and so on and so forth, because Breton . . . , and then one day instead of 'because Breton' it was 'because Duchamp,' and I said 'Duchamp? Who's Duchamp?' and so he began to talk about Duchamp. His attitude was, if you don't know

Duchamp, you don't know anything, if you don't know Duchamp, you don't even have the right to pick up a brush. At the time, one of the most important things available on Duchamp was the article that Matta and Katherine Dreier had written together, and things then were very different. These days just about everybody talks about Duchamp, but back then not even the critics knew who he was, at least not most of the critics here in Italy, and I'm talking about people who were thought of as important and well-informed. When Duchamp came to my first show here in Rome, people simply overlooked him or thought of him as some curious survivor who had mysteriously abandoned painting in the 1920s. Nobody knew anything. So it was Matta who first began to get me interested in this man, Matta with all of his intellectual terrorism and that way he had of defining Duchamp as someone you absolutely had to know about and always hold in mind.

At the time, then, I was already becoming involved with a very complicated kind of painting, and this was at the beginning of the 1960s, which was a period of really enormous development for me. I was breaking out of the life I had lived before and I was doing it in a thousand different ways. I'd begun to do very large paintings on paper that was glued to canvas, paintings with enormous white spaces where I was drawing images that came out of various kinds of objects, images that were almost anthropomorphic and that could look like heads and torsos and parts of the body. Other things were constructions made of planks of wood that had been used to support pieces of metal being worked on a drill press, and they were therefore all full of shallow holes of various diameters. I'd go and dig these things up out of the shipyards,

which were places full of all sorts of memories for me, memories of their odors, memories of the harbor at La Spezia, the whole atmosphere of the war, there was that and then the broken telephones, not so much telephones as switch boxes, the innards of switch boxes full of relays, things that looked as though they were all about thinking. I was gluing things down and welding as well, old locks and keys that will begin to turn into heads and profiles when you concentrate on them, I'd weld it all down to a sheet of metal, there were tubes and nuts and bolts, and it was all very complex. Simply as images, the things I was involved with were all quite complex, and this complexity had in some way or another derived from that first particularly penetrating statement by Matta: I'd taken his advice really very seriously when he'd said to take all of the individual things I'd been doing and to put them all together.

This was a period of a real explosion of interests and activities for me, and a part of it was getting into Duchamp, getting into the work he had done, and getting into it mainly through the monograph by Robert Lebel. That was how I began to understand who this man really was, and right from the start I found him extremely fascinating. Lebel's book on Duchamp is really fine. The tone is right, he's precise and clear, and you can tell that he and Duchamp were old friends. He's discursive and informative and full of humor, there's none of the exegesis that you find with Breton and his 'Phare de la Mariée,' but I was soon reading into that too, into all the history of Surrealism, all the history of Dada, I started getting interested in Picabia, and I also ran across Sanouillet's book on Duchamp, *Marchand du Sel*, which was absolutely fundamental. If I remember right, it contained all the notes for

the *Green Box*, and a good deal of other material as well, but not the *White Box*, which must have come out later. It was strange. It's not as though these notes were any immediate revelation for me, and I wouldn't even say that they immediately aroused a great deal of enthusiasm. It was all stuff that I didn't know anything about or have anything to compare to, and it's all tremendously arcane and terribly specific, but that was just the point. My first impression of this work was that something very important lay behind it, rather than within it, something very important and extraordinarily mysterious. It was all so entirely new. And it didn't have anything to do with any of the other things I had read by great artists, nothing to do with Klee, nothing to do with Kandinsky, nothing to do with Léger or with anybody else. My only point of reference was to think of Duchamp as working in an area that I had previously thought of as belonging only to Roussel and his *Impressions d'Afrique*, which impressed me more than his other books. Roussel was still another recent discovery, and there was a place in my mind that he and Duchamp began to share. They were together for me, and in a way they still are, even though I've since come to see them in two entirely different lights. There's something laborious and mechanical about Roussel, and Duchamp never thought of him as anything more than a starting point. Roussel is finally a rather minor figure, and not at all the kind of presence that can grow really to fill up and change your life—he's not, say, a writer like Joyce. *Finnegans Wake* was another acquaintance I was making at the time, and that was just as important as getting to know the work of Duchamp. All of this was taking place in the space of only a couple of months, at most a year. Joyce must really have come a little later than Duchamp. It's hard to remember exactly

what happened when, since the whole point of this time of my life is that it was a dizzying series of extremely intriguing encounters, one right after the other. And what they had in common was the way they opened up beyond the area of abstract expressionism, or the cultural premises of abstract expressionism, which was the world I'd been interested in before, or was at least accepting as a new avant-garde on the basis of the things you could see in the art magazines: people like Motherwell, De Kooning and Jackson Pollock.

So Duchamp, at least at the beginning, was just another new stimulus among many. But on the other hand, he had the special fascination of still being alive. I mean he was actually there, and he had an address in a phone book, and if you felt like it, what was to stop you from going to take a good look at him and finding out what he was really all about? And Matta was always talking about him, Duchamp this, Duchamp that, and so on and so forth, and we also had a lot of friends in Paris who knew him. They were mainly a group of Peruvian painters—Rodriguez, Piqueras, Ejelson—there was a whole group of them, and all of them were friends with Marcel. Spanish was their mother tongue and they'd spend the summers on the Costa Brava in Cadaqués; they liked the food and the music and the language, and Dalì was there, Dalì and Duchamp, and they were on very easy terms with him; with some of them I think he played chess. These were the kind of people who always appealed to Marcel; he was always interested in artists and especially when they lived like artists. He liked to go to the Coupole or the Dom and stay up till all hours of the night, and that's the way he lived. That was his world, that's what an artist's life in Paris

used to be like. And he was especially close to Rodriguez, who was especially close to me; Rodriguez was the only one who ever addressed him as *tu*; even for me he was always *vous*. He addressed me as *tu*, and every now and then when he was particularly affectionate I'd reply in the same way, but then I'd slip back to *vous*. I mean he was a respectable old gentleman and not at all the kind of person you'd slap on the back. In any case, I told Rodriguez that I'd like to meet Duchamp, and he promised to introduce me as soon as some occasion might arise. And then one day, he phoned me from Milan. Duchamp and Teeny were there and a group of painters was holding a lunch in his honor at a restaurant that day out along one of the canals. It was spring, I remember, since lunch was served outside, it must have been in May, or maybe in June. There was a trellis covered with flowering plants, a wisteria bush or a sweet-pea, it was one of those serene old Lombard inns that now you can't find anymore. So it must have been about nine in the morning when I got this phone call, I was in Rome, nine or nine-thirty, Rodriguez gave me the address and I went to the airport, caught a plane to Milan and then took a taxi out to the canal where the restaurant was. I hardly knew anyone there, but I introduced myself and said that my name was Baruchello and that I'd come to meet Duchamp. Crippa was there, and Baj, and Dangelo, and Arturo Schwarz, and of course Rodriguez. Aside from Rodriguez, Baj was probably the only one of them that I already knew, and I think that he was the one who'd introduced Duchamp to Schwarz. It must have been that Baj had been in Paris and that he and Duchamp had come back to Italy together. Maybe it was Baj who was giving this lunch, I don't really remember, but in some way or another Baj had some particular kind of importance, maybe

Duchamp was staying with Baj. I remember that I was talking to Baj and Duchamp together when I told Duchamp how much I was interested in his work and that I wanted the chance to get to know him better and to talk, to ask him some questions about the things he had done. And he was immediately very charming and suggested that we might get together again on the following day, which was about the best thing I could have heard, so I offered to take him to lunch at Villa d'Este on the lake at Como, and so that's what we did. I rented a car and went to pick him up with Teeny, and Baj drove out on his own, I think with Arturo Schwarz. Villa d'Este was still a very good restaurant then, and the odd thing was that they were having a wedding reception when we got there. There was a bride all dressed in white, and everybody laughed at the coincidence, but the nice thing, the important thing was that we really got into conversation and I asked him about the parts of his work that interested me. But I guess that must have been later. I remember lunch as having been a little more general than that with the kind of talk that people make when they don't yet know each other very well, nothing futile though, nothing with Marcel was ever even close to futile. Even in the very simplest conversation, everything he had to say was brilliant, and perfectly said, very human and extremely simple, just the way Teeny now remembers him. His simplicity, though, was always an emanation of his intelligence, and he was enormously intelligent. Even in simply changing a subject he would go about it beautifully, and his simplicity was something that nobody really simple could ever possibly have managed.

It wasn't until we were back in the car and on our way to return to the city that he talked a little more about

himself and the things he'd done in his life. I remember how he said that what he'd really wanted to do was to make a catalogue like the Catalogue of St. Etienne, which was a company that made munitions, I think, and maybe bicycles too, but they also sold things for just about every other possible kind of company and their catalogue was like the Sears and Roebuck catalogue, which is to say that it was a compendium or a listing of just about everything, an inventory of every human obsession; of course, he'd said it before and he said it again, it's not that he had to change his explanations of himself because he'd just met an unknown Italian painter named Baruchello. The idea was that art has to have that same kind of clarity. And I asked him too about some of the things that he'd done in the *Large Glass*, about the whole idea of the 'passage,' and I was already interested in his notion of the *pendu femelle*, which seemed to me like a uterus, I mean the idea of hanging or being hanged and fertility all at once. I don't know how true or exact that is, but that's the way I felt about it, and that's the way it has always entered and re-entered my experience. I've copied it any number of times, not copied it, but made drawings of it, and that's the kind of feeling it contains for me, that's the feeling I have about it that makes me situate it where I do in my mind. I guess the whole area of what we were talking about was in that slice of his work that goes from the things he did in Munich, like the *Bride* and the *Passage from the Virgin to the Bride*; and what I found so odd at the time was the way all of this extremely erotic and sexual iconography had later been rendered so abstract and skeletal in the *Glass*. The passage from the *Bride* in paint to the Bride in the *Glass* was what I found so terribly intriguing, and why it had to be so thoroughly sublimated, if that's the word, sublimated into

techniques that have finally so little to do with anything painterly, and what was the meaning of the whole idea of transparency. I was still very much attached to the idea that the *Passage from the Virgin to the Bride* is an extemely beautiful painting, I mean just in the way it was painted and the colors, I was still totally a painter and hadn't really entered the spirit of the Ready-mades or the *Glass*. So my questions weren't ever directed precisely to the heart of the matter or to ideas like starting out from the *Bicycle Wheel* and talking about the possible meaning of the appropriation of an ordinary object, or simply nominating it or promoting it to a work of art, I mean from just a bicycle wheel to *Bicycle Wheel*. I remember that all of the questions I put to him then were concerned with a previous terminology. But more than anything else, I was trying to figure out what to do next, or rather what was possible after Duchamp, or made sense after Duchamp, even though that of course was something I was silently asking myself and certainly not voicing out loud to him. And that's the way it was. We met and spent a day together and then I had to go back to Rome, but before I left I invited them to come and visit when they came to Italy again, and they did, which was only a few months later. They came to Rome in 1963 and stayed with us, and that was at the time of my show at La Tartaruga; which wasn't of course just an accident. I knew they were coming and put off the opening of the show until they arrived, and that was very important for me.

The things I was showing in that show were already a little different. I'd decided not to exhibit the objects I'd done before, but only the images; it was a show of paintings with large fields of red lead, horizons, and one of them

was called *Flow Sheet*; some of them were on graph paper, and even though Duchamp wasn't interested in painting, he didn't seem actually to dislike them. But that doesn't mean very much since he was always more likely to be interested in an artist than in the artist's work. He simply must have liked the idea of the kind of person that I happened to be—a kind of person who was full of contradictions and escaping from an entirely different world at a time when I wasn't any longer just a boy. And he wasn't at all indifferent to the desire I had to learn something from him. But there's no way really of summing it up, and all I can say is that there was something about the situation that appealed to him, and he was very kind. He answered my letters, little things like that, a way of staying in touch with my work. He and Teeny even talked to Ekstrom about what I was doing—Ekstrom was his dealer then—and that's how I had my first show in America. The respect that people had for Duchamp was truly extraordinary. He and Teeny simply remarked that they'd seen some curious work by an unknown Italian painter and Ekstrom booked a cabin to Italy to come and look at what I was doing. I remember driving down to Naples to pick him up. That's still another answer to the question *à quoi sert Marcel Duchamp?* and it wouldn't be honest to overlook it. There was also a perfectly practical side to knowing him; he was the sort of person who could give you a hand, and he understood the importance of a gesture that could make you feel that there was a point to what you were doing. That's something that gives you the energy to keep it up, and that was important in the kind of world I was living in, since Rome can be a place of extraordinary indifference. People even snubbed the party I gave for Duchamp. None of the critics came at all, only people like Schifano or

Guttuso or Emilio Villa thought it was worth their while. The only establishment people with any kind of interest in Duchamp were Palma Bucarelli and Argan.

But the important thing was learning how to make a more intimate use of Duchamp and that didn't come until later. I mean there was more to be done with him than just to have made his personal acquaintance. It's important, of course, for a person to have a face, and you understand a man through his physical presence in a way you can never manage through a book, if only as a question of how he tells you what he's got on his mind, but I didn't really start to feel the full scope of his importance until I was ready to explain it in terms of my own. And that was a phase, if you like, of analyzing his work, a phase of working on a groundwork that his work made possible; but, as I said, that came later. At the beginning I was mainly aware of the comfort of somehow having transformed this sacred cow into a kind of household presence, let's say of having tamed him into a dimension that was personal and not just a myth. It was a kind of appropriation of Duchamp, which is fairly frequent in the friendship between a younger person and someone who's a great deal older. You more or less take possession of people who are well-advanced in years; you want everything they have inside of themselves, and you want all of their experience to pass directly into you as though you were receiving a blood transfusion. You have the feeling that you want them to tell you everything they can before they die. It's as though Duchamp entered my life to make up for some kind of missing reference point. He was like the father I'd always wanted to have but didn't, a person the way people are supposed to be and with attitudes I could like and respect and use for real nourish-

ment. He wasn't the kind of father you have to fight your way free of in some sort of Freudian iteration of slaying the head of the tribe and taking his wives and cooking him up in a cannibalistic feast. That's not what he required of you. He was splendid. Olympian and entirely apolitical. He'd had all the women he had wanted, but he'd never challenged anybody to a duel. He had his words, and that was enough. He smoked cigars, but not in the car, because he realized the smell was awful and he wasn't interested in making you prove your virility by putting up with it and not getting sick. There were all sorts of things like that about him, some of them important and others that were very subtle, and all of it went to make him a person with an incredible physical charm. An extraordinary elegance. In his attitudes, and even in his movements, in the way he could draw together the ends of a discussion. He had an unlimited verbal finesse. I think that may even be one of the things that made us get along. He probably liked me because I was easy and comfortable and sometimes quick with words, and not because he thought I was good as a painter. He understood that there was a world of words behind the images I was making. There were words in the titles of them, words were written on them, they had a funny and almost narrative relationship to objects that I'd made before doing them. He found something somewhere in all of that to be convincing.

-toir. On manquera,à la fois,de
-moins qu'avant cinq élections et
aussi quelque accointance avec q-
-uatre petites bêtes; il faut oc-
-cuper ce délice afin d'en décli-
-ner toute responsabilité. Après
douze photos,notre hésitation de-
-vant vingt fibres était compréh-
-ensible; même le pire accrochage
demande coins porte-bonheur sans
compter interdiction aux lins: C-
-omment ne pas épouser son moind-
-re opticien plutôt que supporter
leurs mèches? Non,décidément,der-
-rière ta canne se cachent marbr-
-ures puis tire-bouchon. "Cepend-
-ant,avouèrent-ils,pourquoi viss-
-er,indisposer? Les autres ont p-
-ris démangeaisons pour construi-
-re,par douzaines,ses lacements.
Dieu sait si nous avons besoin,q-
-uoique nombreux mangeurs,dans un
défalquage." Défense donc au tri-
-ple,quand j'ourlerai ,dis je,or-

-onent,après avoir fini votre gê-
-ne. N'empêche que le fait d'éte-
-indre six boutons l'un ses autr-
-es paraît (sauf si,lui,tourne a-
-utour) faire culbuter les bouto-
-nnières. Reste à choisir: de lo-
-ngues,fortes,extensibles défect-
-ions trouées par trois filets u-
-sés,ou bien,la seule enveloppe
pour éte-ndre. Avez vous accepté
des manches? Pouvais tu prendre
sa file? Peut-être devons nous a-
-ttendre son pilotis,en même tem-
-ps ma difficulté; avec ces chos-
-es là,impossible ajouter une hu-
-itième laisse. Sur trente misé-
-rables postes deux actuels veul-
-ent errer,remboursés civiquement,
refusent toute compensation hors
leur sphère. Pendant combien,pou-
-rquoi comment,limitera-t-on min-
-ce étiage autrement dit: clous
refroidissent lorsque beaucoup p-
-lissent enfin derrière,contenant

-este pour les profits,devant le-
-squels et,par précaution à prop-
-os,elle défonce desserts,même c-
-eux qu'il est défendu de nouer.
Ensuite,sept ou huit poteaux boi-
-vent quelques conséquences main-
-tenant appointées; ne pas oubli-
-er,entre parenthèses,que sans l'
-économat,puis avec mainte sembl-
-able occasion,reviennent quatre
fois leurs énormes limes; quoi!
alors,si la férocité débouche de-
-rrière son propre tapis. Dès dem-
-ain j'aurai enfin mis exactemen-
-t des piles là où plusieurs fen-
-dent,acceptent quoique mandant
le pourtour. D'abord,piquait on
lignes sur bouteilles,malgré le-
-ur importance dans cent séréni-
-tés? Une liquide algarade,après
semaines dénonciatrices,va en y
détester ta valise car un bord
suffit. Nous sommes actuellement
assez essuyés,voyez quel désarro-

porte,dès maintenant par grande
quantité,pourront faire valoir l-
-e clan oblong qui,sans ôter auc-
-un traversin ni contourner moin-
-s de grelots,va remettre. Deux
fois seulement,tout élève voudra-
-it traire,quand il facilite la
bascule disséminée; mais,comme q-
-uelqu'un démonte puis avale des
déchirements nains nombreux,soi
compris,on est obligé d'entamer
plusieurs grandes horloges pour
obtenir un tiroir à bas âge. Co-
-nclusion: après maints efforts
en vue du peigne,quel dommage!
tous les fourreurs sont partis e-
-t signifient riz. Aucune deman-
-de ne nettoie l'ignorant ou sc-
-ié teneur; toutefois,étant don-
-nées quelques cages,c'eut une
profonde émotion qu'éxécutent t-
-outes colles alitées. Tenues,v-
-ous auriez manqué si s'était t-
-rouvée là quelque prononciation

MARCEL DUCHAMP: Rendez-vous du Dimanche 6 Février 1916, 1916. Typewriter and ink on four postcards, with tape; 11¼ × 6½". Philadelphia Museum of Art: Louise and Walter Arensberg Collection.

None of this, though, is really important, or at least it doesn't have the kind of importance that would make it a possible basis for a book. These aren't the kinds of thoughts I feel a need to come to terms with. Knowing Duchamp was something that made a difference to me, but the most important difference he made is something difficult to define. It's easier to talk about Duchamp when you're talking about something else. It was easier to talk about Duchamp when we were talking about Agricola Cornelia; he slipped into the argument almost unobstrusively since the argument revealed that it had a place where he was suddenly and unexpectedly pertinent. That's one of the most curious things about Duchamp; he's always appearing in unlikely places, in unlikely contexts. That's a part of the mystery of him, and that's what makes him effective as an *empêcheur*. But when you try to face up to him directly, you immediately run into difficulty, and you don't quite know what to talk about. The discussion of his work is something that I'm entirely willing to leave to others. I don't particularly like what the critics do with Duchamp, but I likewise don't want to set myself up with the pretence of doing the same thing but better. What I see as needing to be done with him is something entirely different. But his lesson was extremely subtle, and the things that make him really interesting are hard to put into words.

I'm interested, perhaps, in the way his works often seem nothing more than indications or emanations of a myth that lies somewhere behind them, and that's a difficult thing to have the courage to affirm. It's as though you hesitate to make him run that great a risk. If a man is just a painter, he's either a great painter or he's not, and his

works are either beautiful and important or they're not, and he's either a central part of the tomes of the history of art or he finds some dignified corner in the footnotes. But to say that the importance of a man is the myth of which he's the center is to make him run the risk of being either everything or nothing. A myth is something alive and it has to live in the consciousness of a great many people—though I wonder quite how many—and if it doesn't it's nothing, it's dead and exists as having been only a passing illusion. The difference is that a myth is something that moves and exists on its own and has its vital forces within it, and an illusion is something that others have wanted to call into existence and that manages actually to exist only for as long as they're around. And so what are these forces that one ought to appeal to in Duchamp? What are the strengths that he gives and how do you find access to them?

Lyotard says that Duchamp's greatest work is his words, and there are times when I think I agree with that. The words that he wrote and the words that he said. Somehow or another. That's a very different thing from the images that he made—all of these curious and disquieting objects that he called his works of art. His words are the 'alphabetic filter' that he talked about. His words are all the words he put in front of or behind the *Glass* or *Etant donnés*, the things, let's say, that he painted. And he wasn't involved with the kinds of words that a painter might use to explain his doctrine as a maker of images. He never talked about realism or non-realism, he never said that a painting is supposed to represent some this or that, he spoke in riddles and puns and conundrums that seem as though they ought to recompose themselves by magic, as

though some illumination ought to reveal them to be a unified whole. It's as if you're supposed to put it all into a giant computer that would reduce these words to some sort of message, some lapidary soul-shaking banality, but that's something, of course, that a computer's never going to do. A computer will write his concordance for you, but it's never going to do anything more than that. What we'd like this computer to do is something we have to do for ourselves. We have to put these words inside our heads and what they're to do there is to fuel some instrument that's parallel to the instruments that he himself was involved with using, an instrument involved with the formulation of languages and hypotheses that are connected to art, and these are languages that in my own particular case are my own life history, and in the case of somebody else they'd be another life history, and that's what we're involved with rather than trying to make some critico-analytic experiment in reliving the experience of Duchamp in the way he lived it himself. That may not remove the problem of the relationship between Duchamp's words and the works he made, but if such a problem exists, it's not at all to be taken for granted that we have to feel that we want to solve it.

I'm more interested in saying that you get involved with Duchamp in much the same way that you walk into a forest. And a tree may be older than another tree, but that doesn't make any difference since it's still a tree, no matter if it's taller or shorter, it's still a part of the forest. And as you move about in this forest, you begin to understand that it's full of secrets; you begin to realize that it's haunted by spirits; you realize that this forest is the locus of your house, or your lair, and your fear as well, if you want to

have a look at it. The work of a person like Duchamp is very close to such an ancestral image of a forest, at least for me. It's more that than anything else. Duchamp's not a house. Duchamp may at some point have employed the idea of a house and I once made a painting of the interior spaces of a house as Duchamp might have used and defined them, but really I see him, rather, as an enormous forest. And I think of a forest as a place that's difficult to understand and to find your way around in; it's a place where you can lose yourself, a place where anything at all can happen, a place that can cause the invention of a fable or stimulate the discovery of trigonometric calculations that tell which way is north and which way is south. And the only way you can relate to such a place is by trying to relate to *all* of it; you see all of its aspects and possibilities and implications as things that have to be understood. But before you become an explorer, you can also just visit it, you can go there on a picnic or enter it every now and then just to hear the singing of the birds or the hoots of the owls. You can enter the world of Duchamp's words for the occasional experience of permeating yourself with the chill of those gelid hallucinations of which he was surely the greatest producer. Rather than sniff a flower and let the perfume of it go to your head, you absorb a pun and watch it sink to the pit of your stomach. Your purpose in doing this doesn't necessarily have anything to do with trying to figure out why he painted, say, the work called *Tu'm*. And that's not to say that figuring it out would be a waste of time. It's a painting nobody ever talks about, and it's got that funny title, and there's a safety-pin in it, too. Why should there be a pin in it, and the hand, why is there a hand in it and the shadow and the bicycle wheel, why that rather than the coat hanger? You could get involved in

that and speculate all of your life, and that's where the scholars and critics put in their appearance and say that he met so-and-so and thus and forthwith and therefore, but that's not at all what interests me. If the way his words connect to his images is something that escapes me, how much of a difference does that have to make? Not very much at all. One of the things I can do with him is simply to take his words as a place in which to make some sort of safari, all of the words, all of the notes, and especially the most recent things published by Paul Matisse, that and the book by Cabanne, it's all a series of puns and wisps of projects and half-formed phrases. That's what it's for, it's a place to visit on safari, to see what's there, to see what sort of game we can use it for, what we're doing now is the game and we're the people who are playing it. That could be a book called *Etant donné Marcel Duchamp*, where the *étant donné*, the 'given,' implies accepting him whole and with all of his complexities and in the way he developed through the years or resisted the developments that were taking place around him. Duchamp, say, as a time machine, Duchamp and his words as having ignored some kinds of changes in the world and perhaps as having accelerated others. And I wouldn't see that as implying that he was really a writer who made a few curious objects as a kind of support for his words; it's obvious that it's quite the other way around. I've always insisted that Duchamp is a painter and poorly understood as anything else—a great painter who was always involved with paintings, and paintings are the things you see at exhibitions and there have to be rooms in museums to hang them up, that and all the rest of it. He was interested in that; there's a point where he says that any number of geniuses in art may be lost off somewhere in China where they'll never know *la gloire*, and that's

what he wanted for himself; he wanted *la gloire,* he wanted it as a painter, and that's what he was, he was a painter. But he's also the very first painter to have made paintings *d'aprés parole,* and that's why his words are important for me; it's not that I want to analyze them or build an hypothesis around every scrap of paper he scribbled on, it's simply that he was the first great painter *d'aprés parole.* That's my first point of contact with him since I too am involved in painting from words, things that enter a kind of *jeu d'idées* rather than just a *jeu de mots,* things that work on the idea of trying to see what happens if you put together politics and science, philosophy and poetry, painting and psycho-analysis — trying to see what happens if all of these things are put together and mixed up in a cultural cocktail shaker. Do they manage finally to coalesce into a sarcasm and some new form for 'a modest proposal,' do they shape themselves into nodes that explode into polarities where all sorts of contradictions are yoked together, do they excite extremely complex thoughts that create philosophical syntheses, illuminations, moments of awareness, and little epiphanies that last for only a second, do they constitute a mechanism for creating complications and miming the dream as though to make parallel dreams exist contemporaneously while exciting the absurd on the one hand and the paralogical on the other, and how does that slip towards the idea of the comic? And even though all of these problems are explored through images, fundamentally they're much more verbal. I've always insisted on the possibility and necessity of talking about Duchamp as a painter, but my own experience as a painter is an experience full of words. Cabanne at one point asked him how he felt about Breton's having called him the most intelligent man of the century, and his reply was beautifully apt; he

said that the logical or Cartesian form of intelligence—
which is what people usually mean by the term—isn't at all
what Breton had in mind. And then he made the argument
more general by saying that intelligence is something
that's worth a great deal more than what a dictionary
would give one to believe. He said that the meanings of
certain words 'explode' and leave dictionary definitions
behind them. And all of his work could be interpreted as a
way of giving meaning and value to things that don't make
sense from simply dictionary points of view. It's as though
he'd been trying to give them meaning for some possible
future dictionary; his dictionary included rubrics from the
inconnu and the *inframince*. He even talked about a diction-
ary of macro-enlargements of details from previously
existent photographs as though he were interested in re-
vealing molecular structures, or something on that order.
He was just as fixed on the idea of lists and dictionaries as
he was on the idea of a catalogue. He had a love for every-
thing involved with listing things, and he declared that
quite clearly. You told me too that he was friends with the
artist Carolee Schneemann and that she now remembers
how he'd always ask her, whenever they met, to recite the
litany of place names from where she had lived in Illinois,
names like Tolono, and Pesotum and Rantoul and Foos-
land, and he'd sit delighted and listen as she rattled off
dozens of them. You see the same thing still again where
he talks in *Notes* about colors, first the 'chocolate' color, the
possibilities of the use of iodine as a color, shaving cream
or tooth-paste; and even if the way he develops it doesn't
make for a very simple list, since it's full of transversals and
broken into a thousand pieces, the idea of the list was
always there in the background. All of these things were
fundamental for him, and this is another of the more

specific ways in which he was really useful to me. It's not as though I suddenly said, 'Eureka! Why not make use of Duchamp's idea of catalogues and dictionaries and lists?' but oddly enough the first important show I did was called 'Instructions for Use and Maintenance.' He simply comforted that impulse in my thinking. What he always gave me was more a question of confirmation rather, say, than inspiration or stimulation. I surround myself with archives, I've done all sorts of lists and accumulations and boxes and drawers and each of them is really something on the order of a brief in a file cabinet: a brief on the concept of the ass, or the class struggle, feminism, the house, the idea of the omnibus, the techniques of solitary navigation. For me, these are like the things that Duchamp finally pulled together in his secret room, and maybe one day I'll make a definitive and final archive, definitive and final of course for me, or an inventory of all the things that clutter up my mind in a way that implies that each of these things is a complement of all the others, and that what they're looking for is the secret of what all of them can mean together. When I imagine that someone may some day come up and say, 'But what are you really up to, Baruchello?' there's a comfort in thinking that I'll be able to reply that I'm working on an archive. And part of what allows that to be felt as a comfort is the way Duchamp declared that a thing like that is worth being interested in. Being detailed to archiving is normally something of an insult; it's a form of boredom that nobody with a mind imagines he should ever be forced to practice. But that's the ordinary definition, the ordinary point of view, and Duchamp offers another one. I'm working on an archive that's different from anything that he would ever have done, but archives and lists and dictionaries are all the

same thing and he could be called an archivist too. That's a perfectly possible definition of what he was doing; he was involved in making archives that were ambiguous and disordered and he worked with a system of simple ostention. Ostention in the sense that he often seemed to be saying, 'Well, what am I going to do with that?' And the answer was always, 'I think I'm just going to put it over there, just put it there and see what happens.' And maybe he didn't even have the idea of seeing what would happen; it was more like putting it there and leaving it at that. He never bothered to classify things; giving them places was enough — putting them in places where they could be seen by somebody, putting them in places where he himself could see them.

What intrigues me is that this sort of relationship should exist between two such different people, people in different periods, people with different kinds of talent, different habits, different kinds of physical presence, different ways of relating to the people and the world around them. It's curious that there should be something Duchampian in my work when there's certainly none of Duchamp's way of living in my life; at that level, it would be difficult for two people to be more different. And you can't explain the relationship by thinking it was somehow planned on; it's not at all, say, that I'm a student of Duchamp's, not that at all, not a student or a follower at all. It's not that I ever feel that there's something I can or ought to do because Duchamp before me did something else, or something similar, or somehow broke the ground for it, not that at all. It's rather that there was a period in my life when I went about doing the things I do and found a pleasure or a comfort in the fact that this kind old gentle-

man had a certain affection for me, that there was a possibility of exchange with him, that there were simply things we could talk about. And then, after his death, I kept on finding this same sort of comfort in the works he had done and in the things he had written and had to say. He remained a presence that I kept alive through a very intense interior dialog, a dialog made even of reproofs and a desire, say, to put him in a proper perspective by remarking on all the things he might have done and didn't. It was as though I were asking him why he hadn't been in Madrid at the time of the Spanish Republic and it annoyed me that the only people who had done things like that were people I couldn't really care less about, people like Malraux. And after a while, I saw that these recriminations didn't really make much of a difference. You'd have a fairly stupid cosmogony if it couldn't make room for people who didn't go off to Madrid, and Duchamp's not having done that sort of thing didn't lessen him for me, finally, at all. There will always have to be room for people like that, the kind of complex and curious and distant personalities whom Artaud described as having *besoin d'un intérieur*. But this mood of reproof was something I had to go through, and now I can see Duchamp in a different political light that wasn't in any way clear to me when the things that kept coming to mind were concerned with how he'd never been even remotely connected to the most important political events of his times. Now I can feel that he made his own version of the October Revolution, a kind of silent revolution, a personal revolution that had something to do with just being able to be content to sit where he sat and to smoke his cigar. And no, it's not that we're likely any time soon to forget the October Revolution or to cease to see its importance for the way the world and our lives are going

to have to become, but you can say, perhaps, that our vision of the October Revolution is destined to become ever more prosaic. And long after the poetic side of the October Revolution will have withered quite entirely out of sight, we'll still be in the midst of discovering that lots of little personal October Revolutions took place at much the same time and amount to something really eternal, at least as material and stimulus for reflection. But maybe these are things that I should only say to myself, since hearing them spoken out loud makes me wonder if they're not just nonsense and lyrical associations that it's not worth the time to make.

In any case, I'm surely on safer ground when I remark on the way I relate to Marcel through affinities with many of his notes on how things ought to be done — on manners, say, of procedure. Any number of his notes, for example, are hypotheses on how to go about the execution of an idea, hypotheses he was then content to leave as hypotheses and never to make use of. But even though he'd discard them as not practicable, he'd keep them anyway, and they had some sort of value for him. They represented what he thought of as a valuable way of thinking. A way of thinking where ideas are always tumbling from one delirium to another, which is like a folder in my archive marked 'How to Write the Book.' His notes are full of things like that, projects and tiny blueprints, and even though he was happy to make the statement that his life was never dedicated to getting up every morning and respecting the painter's obsession of constantly having a drawing to make, there's a way in which that's not entirely true. He may not have been obsessed with making drawings, but there was always some note or another that he

made on a ticket for the trolley car, or on a coaster in a beerhall, or the bill at the bar: for all of his life, these were the places where he recorded all the things that were important for him, all the words and all the images and ideas that these words were concerned with, all of his hypotheses, his puns and plays on words, the flashes and strokes of genius that came to his mind, and now we've got all of this stuff to deal with. So it's not really that he spent his life in cafés doing nothing but smoking cigars and playing an occasional game of chess. I'm a little tired, really, of this myth of Duchamp as a kind of Holy Man in retreat, even though it obviously served his purpose in some way or another to nourish that sort of myth, and he did have a way of nourishing it. But now we can also see that he created a whole landslide of material that continues to flow into our lives from out of the publishing houses, and it contains things it makes sense for us to deal with. And how can you not connect that with his fascination with the idea of 'the delay'?

In a way, it's a question of form, in the sense that he was the great master of the *inachevé*. The only thing he ever really finished was that last room of his, *Etant donnés*, and that was perhaps completed by his death. The way the *Large Glass* was left unfinished is a kind of symbol of everything he did, and that's a part of the very nature of the Bachelor Machine. Finishing things means reproducing yourself. It means having a copulative relationship with the world and pulling things into a cycle that determines a sequence of descendencies; but for Duchamp, masturbation was one of the most fundamental symbols of all. You can see that as early as the *Chocolate Grinder*, and everything he did from that time on seems a part of what gives him his

weight, since the idea of leaving things unfinished is also connected to the idea of death. Life, after all, is what's always left unfinished. When somebody dies, you always say, 'But he was just about to make a trip to someplace,' or something, or that he left two children and a widow, and what's to happen now. It's only very rarely that people consign themselves to death with the idea that they've done everything they had to do and that death is arriving when it should.

But there are so many ways of possibly talking about Duchamp, so many arguments it might make sense to construct around Duchamp as their possible center, so many titles for so many possible books. *Duchamp and the Idea of Interruptus*, or *Duchamp and the Inachevé*, or *Duchamp and the Dictionary and the Archive*, and that's no more than the very beginnings of a list of possible essays that it's very improbable we'll ever get around to writing. You could go on from there, say, to *Duchamp and Doubt*, or *Duchamp and Plumbing*, or *Duchamp and Emptiness*, or *Duchamp and Transparency*, *Duchamp and Solitude*, *Duchamp and Delay*, *Duchamp and Time*, Duchamp and all of those attitudes, all of those ways of being and thinking and working and living that helped him, finally, to the statement that he was an extremely happy man because of all the things he'd never had: a house in the country, 'what one calls a wife,' a car, any great misfortune, any great personal sadness, any neurosis, only he didn't say neurosis since he prefered the word *neurasthénie*. The only thing I ever saw him worried about was flying in airplanes.

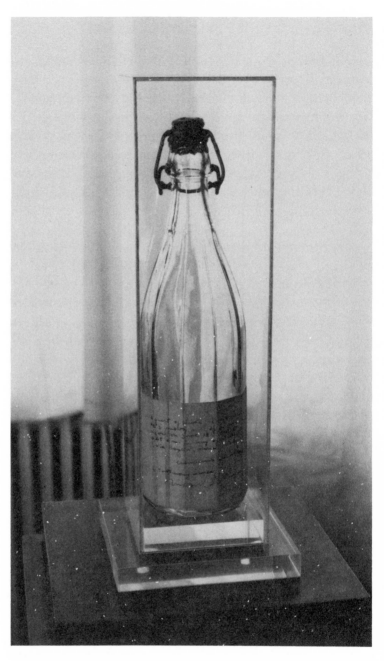

GIANFRANCO BARUCHELLO: *Petit réservoir d'énergie gazeuse: l'exhalaison de fumée de tabac* ("in testimony whereof [signed] Marcel Duchamp"), 1965. Glass bottle, smoke, sealed cork stopper, plexiglass mount.

I once did a painting on a photographic enlargement of a drawing in india ink where you see my face with a phrase written across the forehead: 'You mean me? I'm supposed to explain Duchamp to the sub-proletarian youth movement?' That seemed a horrifying thing to have to do, but here I am, now, trying more or less to do it. Or almost. What we're doing here may not be specifically designed to go into the hands of the sub-proletarian youth movement, but still we're talking about Duchamp from a fairly unorthodox or at least an unusual point of view, and there's still that sense of risk, that sense of an unpredictable audience. And it still might be wise to ask why it has to be me to undertake this task—even if it's a necessary task—of flying into the face of the kinds of dissertations and arguments that other people are usually in the habit of developing around Duchamp. So that painting may have been a harbinger of what we're doing now, if we make a few provisos, including, of course, the proviso that our intention here has really nothing to do with offering explanations. Trying to explain the work that he did would be beside the point, since what we're really looking for is its use value. We're asking what sort of lessons Duchamp can teach, or, better, what kind of lessons he can be proved to have taught, if there's any sense in which that's synonymous with lessons that other people can say they have learned. And the title of my painting was full of irony and sarcasm—which I imagine is still fairly obvious: 'You mean me? I'm supposed to explain Duchamp to the sub-proletarian youth movement?' It's a reference to what was then the typical state of mind of most self-respecting intellectuals in Italy, since it seemed at the time as though nothing had a right to be thought of as true or important or of any kind of interest unless it could be explained to the young and disenfran-

chised. That was the period of the political groups that
began to happen after 1968, the period of global but no
longer Marcusian contestation that in Italy more or less
floundered in Milan at the festival at Lambro Park. In fact,
there's a drawing of a tree in that painting, and there's also
a phrase about 'the super-ego at work at Lambro Park.' The
intellectuals in the revolutionary left had more or less
assumed the existence of a super-ego that was theoretically
endowed with the power to keep youthful discontent on a
properly productive path, but what in fact happened at
this conclave in the park was that the revolutionary left
was practically lynched and declared superfluous and
expendable and of no possible use, importance, or perti-
nence. It wasn't put that way directly, but the crowds
jeered at the homosexuals, derided the feminists, raided
the kitchens and raised riot about the prices of all the food
on sale, even though these prices had been defined along
political rather that economic lines of thought and pur-
posely kept as low as possible, which may even have been
lower than cost. It was the moment when the whole
extreme left more or less went into tilt and came up against
the reality of having no mandate from the groups of people
they had been pretending or aspiring to represent. The
things the various political groups were saying were
already short-circuiting, and their control of the real poli-
tics of their situation was already pretty slim, but Lambro
Park was where the shit hit the fan. It was suddenly clear
just how desperate things had really become, and you
couldn't help seeing any more that the next step was going
to be the shooting in the streets and all the terrorism that
still isn't completely over with. The kidnappings, people
being shot in the knees for all sorts of incredible reprisals,
all of that and the killings and worse. Lambro Park made it

painfully clear that the leftist forces that had defined them-
selves as ultra-progressive were losing all possibility of
keeping things under control. I mean, that was the sub-
proletarian youth movement, and the idea of trying to
make a speech to tell them what Duchamp is all about is
finally an idea that fairly much defines itself. Nobody had
anything at all to say at Lambro Park unless he was talking
about heroin and the feeling of having been forced to live
on the margins of society, and so you can imagine what
sort of reception would have been given to somebody who
wanted to talk about Duchamp and his speculations, say,
on yawning and the enigmas of the *inframince*. You can
think of this drawing then as my usual provocation, and it's
a self-provocation, of coupling the most unlikely sorts of
things — on the one hand the most desperate and extremist
political situation, and, on the other, the most refined and
incomprehensible voyage of the mind. Imagine Duchamp
at Lambro Park, and what he might have done there. He
wouldn't have done anything there except look for a taxi to
get out, or he'd have stayed off in a corner and played the
role of a little old man smoking a cigar, and that would
have been the end of it. It would certainly never have
occurred to him that that was a place where people might
have been amused to hear him announce another of his
quips like the one on the equivalence of *le dos de la cuiller* and
le cul de la douairière — the back of the spoon and the ass of
the matron. The idea really was that what was needed at
Lambro Park was simply someone with sufficient political
intelligence to understand what was really going on. It was
a way of asking where the sub-proletarian youth move-
ment was actually heading, and it makes no difference that
the sub-proletarian youth movement is something that
Duchamp could never have cared less about. It was a way

of remembering that he had all of that intelligence and an enormous capacity for the analysis of things, and as well a very fine instinct for tactics and sensibilities, and I was wondering how things would have been if only someone had known a way of applying those kinds of qualities to a situation like this one, a situation that was revealing itself as a political and sociological nightmare; and part of the nightmare was seeing that the time had come to think a little more clearly about some of our too-fond hopes, about some of the too-fond hopes that had been running through the mind of everybody who thought of himself as a self-respecting intellectual ever since 1968. The whole idea of this festival was that these kids could be won back into some kind of process of responsible politics, but that illusion revealed itself for exactly what it was; Lambro Park was a place where the right thing was to go into mourning, and certainly not to undertake an explanation of the work and thought of Marcel Duchamp. The painting was a way of expressing incredulity in the face of the times and social realities we live in, incredulity in front of the possibility of having to discover that certain kinds of complicated and peregrine discourse simply don't have a public place.

This painting also has a huge cockroach in it, a cockroach out of Lautréamont, as a symbol of desperation; and the figure with my face on it has 'Sodom' written next to it as an identification with something feminine, something neuter even, something unsexed. And where's Duchamp in all of that? Nowhere, except that the painting can also be seen as finally an emblem of the kind of shamelessness I've shown in the ways I've tried to make use of Duchamp as an approach to the most varied and incredible situations —of the way I've used him as though he were

an organ, or an arm, or a leg, one of the body's instruments, or an area of the mind, or a lens to look through, but all of this without any kind of critical reference point, without recognizing any duties in terms of style, without any kind of fidelity to the things he actually said or showed an interest in. I've remained entirely *à coté* with respect to his work and I've permitted myself just about anything and everything, any juxtaposition at all, and that's what this book is trying to do again. And what it's trying to do is inevitably disturbing. This isn't the way we've been taught that artists are to be talked about. I mean, there's no discussion of the work and its various specifics, no comparisons, no precedents, no history, no archetypes, no psychological analysis, or any of the rest of that sort of imbecility. It's entirely a question of looking at what sort of relationship I've had to him, me as a painter to this other painter, and it's an entirely arbitrary relationship, and perhaps an entirely excommunicable relationship from the point of view of the art history experts and all the pure Duchampians. But if Cage can write acrostics about Duchamp—and I was looking at one just the other day—well, if that's possible, then I can do anything else that seems to me, just to me, to make sense or simply interesting nonsense, and that's one of the things that Duchamp himself ought to be able to teach us. Cage can make rebuses, and I can make different rebuses, and it's all entirely legitimate. One enigma is as good as another, and enigma was the territory Duchamp chose to live in, and starting out from there, the thing to produce is still further enigma. There's no reason for my enigma not to be allowed simply because it has gone out and dirtied its hands with some of the social realities around us, gone out and made itself more complicated with some of the kinds of political and social

thinking that have been going on here in Europe for the last ten or twenty years, and especially since one of the aspects of this thinking has been a questioning of the very function of art. People like to imagine the artist as a kind of termite that destroys the mental and ideological underpinnings of a corrupt society, and I don't know if any of that makes sense, but I do ask myself these sorts of questions. I remember having met Regis Debré, and he said, '*Ah, un peintre militant, c'est très rare.*' But that's not the way it is at all. If I'm a militant, it's within the context of painting itself; I don't at all pretend to be Courbet in the midst of the crowd that's pulling down the column of the Vendôme. And a painter almost always has the curious privilege of living through the events of an epoch from a painter's point of view, like the painters who made pictures of battles. Or like the painter who works in the hospital operating room, or who goes into the courtroom to make drawings of the judge and the various witnesses when it has been decided for some reason or another not to admit photographers. There are even situations where you have to call in a painter because technological means of reporting are impossible. Somebody has seen the face of a man who has robbed a bank and the police artist works from the witness' description to draw a picture to print in the newspaper. The areas that can't be approached by technology are where painting and music and poetry have always taken place, and the very existence of these impregnable little citadels of human privilege gives a kind of legitimacy to what we're doing here, a legitimacy to asking the readers of a book to sit down to a plate of cabbages at tea.

The delirium of that drawing—'You mean me?'—lies in imagining an unimaginable moment or condition when

it would be not only possible, but even necessary and fruitful to talk to the sub-proletarian youth movement about Duchamp. We know that the world itself requires the existence of illogic, and the juxtapositioning of opposites, and the creating of situations that go beyond the illogical to discover the paralogical, but we don't quite know when, or where, or how, or to what degree. And that becomes a kind of discourse on the post-modern, or rather on the way the various parts of what they call the post-modern condition refuse to have anything to do with one another. We live in this world that exists as just so many bits and pieces and shards of itself, as a kind of memory of itself which instead of being a memory has stood up on the strength of some evil wish on a monkey's paw and begun to walk; and the philosophers make sense of it all and tell us that the *grands récits* are over and done with and that all of these fragments coexist in relationships that are difficult to define as anything other than states of coexistence. But that's not how the pieces feel about themselves and about each other. Various groups of fragments are always trying to make new aggregations and are busily involved in denying the legitimacy and even the existence of the parts that are recalcitrant to being pulled back together into each of these variously defined ideas of a corpus. You end up having to deal with the perception of the lack of relationship, or clear relationship, between the most advanced forms of aesthetic thought and the social context that justifies their existence and determines their modes of functioning. But there's simply no point any more in trying to live in an elitist idea of art for the sake of art. That doesn't make any sense in the world we live in. Art for the sake of art is just an idea that you have to assume or discover as a basis for research or as a kind of motivation

that has to come to terms with something else, and that something else is, well, it may not be the sub-proletarian youth movement, but it's a question of the things that mediate your own presence in the world, and the world of social reality, the world of needs, the world of concrete needs; how you make sense of yourself is by drawing all of that into relationship with this other world of needs that are infinitely complex, needs of intelligence and creativity, even though 'creativity' is a word that Duchamp wasn't at all fond of. And for whom, precisely, this is important is beside the point. You can't issue an edict and declare it important for people who find themselves galvanized by a perception of the most elementary material needs, and you know those needs will have to be satisfied if the world is to survive. All you can say is that it's important for you, and all I can say is that it's important for me, and it would be silly not to accept ourselves as legitimate realizations of certain not-entirely-mystified forms of human potential. And to keep them unmystified we have to understand that our roots, like the roots of the tree in that drawing, are sunk into something more that the halls of museums or the pages of books. What's important is to realize the need for fundamental and essential discourse at all the various levels of the lives we live, all the levels of the lives that all of us live. It's a question of looking at all the needs with which it's possible to make contact, all the needs you can be aware of either intellectually or otherwise, either as a question of direct experience or as things you have other less direct ways of knowing about. But what's the difference between direct and not direct in the first place? When things are really a part of your consciousness and your impulses to action, there isn't any difference at all. You put all these needs together and what they form is libido and

the entirety of your world of desire. It's so tragic and unjust for people not to understand that this isn't some sort of denial of priorities; we're sitting here in relative comfort and doing something we feel the need to do, but that doesn't mean that I wouldn't be overjoyed if the next elections were to make a radical change in the world we live in. One wonders how much culture and diversification the Giscards and Nixons and Reagans of the world have actually managed to destroy. Duchamp is a person to be approached from any number of points of view, from as many different points of view as possible, and one of those points of view is the most libertarian point of view imaginable, the point of view that's least respectful, least cringing, least interested in upholding the status quo, and that's what that title, 'You mean me?' was getting at.

It's finally not important that Duchamp's space of freedom was a space he found inside the world of the rich. That's not what defines him. You have to go beyond that. I had to get over that habit I had of thinking that all that these heroic avant-garde painters were ever really interested in was going to bed with the richest woman they could find and having themselves kept. If you look back dispassionately to the way Duchamp could say that working was a little bit of an imbecility from an economic point of view, well, can you really say that he was wrong? And isn't that a political discourse too? Any number of people by now have talked about the obsolescence of work, and, as well, about the political right to refuse to be involved in unnecessary labor; and they've talked about it quite respectably and made it a part of real politics, a real force that real politics has to come to terms and deal with. And isn't that what the sub-proletarian youth movement is try-

ing to say too? Isn't it odd that people should have been talking about exactly that sort of thing at Lambro Park where any sort of discourse on this aged gentleman and the way he thought would have been absolutely impossible? But it must mean something for these two situations to have that sort of thing in common, this one situation that was the platinum tip of an elite that began to take shape at the beginning of this century, and this other situation that's the voice of a contemporary and disenfranchised urban sub-proletariat. You can't of course overlook the difference that their answer is heroin and that for him it was sleeping late and with whomever he wanted and piddling and getting through the day playing chess and then an evening invitation to eat oysters at the Coupole, but isn't the attitude the same, or can't you think of these attitudes as extensions of one another? That's something else that might fit into an essay on Duchamp as a time machine. And what other painter could serve as an example of a thing like that? Léger? Comrade Léger, who was painting up on a scaffold along with the workers? Not really, not really at all. And no, I don't want to push on this, it's just an oddity, a kind of rhyme, a coincidence, an arbitrary juxtaposition, but his refusal to see work as a value sometimes seems to me an important thing to remember about Duchamp; those areas of today's young people who think of themselves as marginalized aren't likely any time soon to see their ideological rejection of work accepted as an official part of the platform of the Italian Communist Party, but all the same, there are people now who are starting to say that the problem with the Italian Communist Party is that it hasn't paid enough attention to the positions that are off to its left. So maybe all of this babble about personal revolutions isn't really so absurd after all;

this whole delirious way of proceeding may not be so delirious.

There's still another thing that I think of as important in that drawing: this image of a house made of bamboo and gauze. I've also done it as a construction in some of my objects, and it has been a part of all the work I've done around the symbols and archetypes of femininity, which includes houses and all sorts of closed-in and inaccessible spaces, but here the walls are gauze; the walls are Duchamp's 'alphabetic filters.' And later I discovered that there's a day in the Jewish calendar when the Jews are supposed to build a similar sort of house, a house made of palm leaves and curtains, and it's to be used for readings from certain parts of the Bible. It's a provisory or temporary house that's only supposed to last for a day and it has to be built this way so it can be carried away by the wind. I see it as a symbol of nomadism, since it's a feminine space that isn't in any way stable. You can think of nomadism, really, as a rejection of feminine space, or as a search for a freedom from everything maternal, or maybe as the capacity to return to feminine spaces and construct them whenever you need to or want to; but you don't have a constant need for the space of a house, or the space of a mother, you're a wanderer and you go wherever the wind decides to take you, and you take your wives and your children along with you. And at least part of the reason for having this house in this drawing is that you can see things like that in the life of Duchamp as well, which is perhaps a better, looser, richer, or more poetic way of saying what I was trying to say earlier when we were talking about the way Duchamp remarked that he'd never had a house in the country or an automobile. Teeny mentioned, almost wist-

fully, that they'd never owned anything while Marcel was alive, and that Marcel had never wanted to own anything. The idea of possessing things was unnatural for him, and possessing things brings so many other things in its wake. The house brings the idea of property and connects to a cluster of fears concerned with women and desire; you get involved with an idea of security, an idea of protection, what you're protecting is the woman in the house, and nomadism is exactly the opposite of all of this; you relieve yourself of all these forms of possession, all of these forms of ownership, you relieve yourself of all these objects and at one and the very same time you also relieve yourself of all of your fear. It's like the unleavened bread of the Jews, as they wandered in the wilderness. The bread is unleavened because there's not enough time. There's no time for the bread to rise because you always have to be ready to get up and leave and go somewhere else. And always being ready to leave means never being afraid of leaving, always being free of the fear of leaving, and if you think of Duchamp you're thinking about someone who visited all of the places that he felt like visiting, someone who went anywhere and everywhere he thought he ought to go, and none of the places that he went were places that he wanted to possess and none of these places were ever able to take possession of him.

Duchamp was always the bachelor and the bachelor is always azymous, always unleavened and unleavening, he doesn't produce anything, he's not involved in fecundation. The idea of yeast and of bread that swells and rises is all involved with an idea of something organic, with the idea that bread is something that's born out of a seed of wheat, but the odor of semen, the odor of sperm, is the

odor of grass, an odor of starch; if you roll around in a field
or crush a handful of growing wheat, the odor you smell is
the odor of sperm, and so there's a kind of doubleness in
the nature of bread, maybe too because of the speed with
which it rises, a speed that seems to have more to do with
animal life than with the lives of plants, the speed, say, of
the life of a man as opposed to the life of a tree, and so
bread is somehow animal and vegetable at one and the
same time, which is to say that the sperm, the seed, the
seed is vegetable and the molecule of yeast enters into a
relationship with it, and the flour, the wheat, goes into
fermentation, which is all very fast and complicated, and
what you end up with is bread, which is an entirely new
and different chemical substance, an entirely new and
different personality. Bread isn't just wheat and water, it's
bread, and a chemist could furnish a formula for it, a
formula for what you've got after this process first of fer-
mentation and then of cooking this mixture of wheat and
water. Bread, though, isn't itself a mixture, it's a com-
pound. Which is to say that the idea of 'non-fermented,'
the idea of 'unleavened,' contains the idea of something
that's 'not born,' non-fecundated, the idea of something
sterile, and it's curious that the ritual bread of the Jews had
to have these characteristics. Perhaps it's an aspect of wait-
ing for the Messiah. And all of this may seem like stretch-
ing a point, but certinly no one has more of a right than
Marcel to be thought of as a nomad. He had a house, but
he gave the impression that he didn't; you always thought
of him as being somebody's guest somewhere, like a cer-
tain kind of character in novels by Henry James, a symbol
of always having somewhere else worth going. He was
rootless and always on the move, and that was how he
visited all of these various places of the mind, all of these

places that he then designated with a name, but instead of place names they're the names of objects, names of inventions and subjects of reflection. You could say, for example, that he once made a visit to 'chocolate,' and stayed there for a certain period of time, or that he sojourned at length at *'inframince,'* or *'eau et gaz,'* or that idea of totality he called *'tous les étages.'* And what did he really mean by *'tous les étages?'* Or by *'eau et gaz à tous les étages?'* If a house, for example, has various levels, and if these levels can symbolize levels of morality, in that case what he'd done was to look for these energies in all of them, the energy of water and the energy of gas, and he found them as *étant donnés,* as 'givens,' or rather as the only things that can serve as the basis for some further departure. And so it was almost inevitable for those things to turn up again at the end of his life in his room in Philadelphia with the waterfall and the illuminating gas, and that for him was their natural form since he always saw these forces as something dynamic: for him, the water had to fall and the gas was the gas in a lamp and the lamp is lit. For me, on the other hand, they're only potentials or fuels held in a reservoir, and when I think of water and gas as psychic forces, I never think of the water as falling or turning a wheel, and gas is something compressible and expandable and contained, and it's not necessarily something that could be lit. But he was still the one who told me about the country of *eau et gaz* and when I discovered it, when I visited it, it was there but it was different, or perhaps it's just that I visited it in a different way. We really had very little in common, and my way of going there meant buzzing and spinning about on a point like a fly gone mad, and he was like a lizard immobile on a wall. And this idea of immobility, this idea of not having to move, this rejection of the idea of work, this way he had of

saying that he'd lived like *un garçon de café*, or that he'd never made the acquaintance of neurasthenia, all of that's connected to a way he had of living his life as though he'd been attached to a safety cable; it's not that he was ever involved in *la connaissance par les gouffres* and in throwing himself headlong into the abyss. That's not even a possible speculation since it's absolutely alien to the memory of the kind of presence that he always had. He wasn't like Michaux with his mescaline, he wasn't into that at all. He was quite content to sit at a table in the corner of some sidewalk restaurant and to look from that point of view at the life that passed through him and around him. The only time he ever took LSD was by mistake, or rather because a friend was craven enough to slip it to him in a cookie or a cup of tea. And all he did was just to sit there in a sweat and stay as quiet as he could and wait either to die or get over it. And in fact he got over it and it all went away, he only turned to Teeny to say, *'je suis très malade.'* There was always a leisure in his zig-zag from one place to another and his whole way of reasoning was extremely detached. There was always a quiet happiness about him, and he did what he had to do without running any special or particularly hazardous risks. He didn't need mescaline, and he didn't need heroin, he didn't need any Dionysian experience of drunkenness, he played chess and smoked a cigar and went to bed with beautiful women, and he thought these thoughts that were always almost cold. Even those pieces that he made with a photo of himself dressed up like a woman have an irony about them, an irony and a distance and an incredible self-assurance. That wasn't an easy thing to do in Paris in the 1920s, Breton and the Surrealists were very harsh with Man Ray because he was known to have friends who were homosexuals, it wasn't easy at all to make

those photos, but there's an air of his knowing he could carry it off because his virility was absolutely unquestionable. But still, one doesn't really quite know what to make of that photo. I had a dream once, it's in *The Plexiglass Wardrobe*, a dream where he told me that the secret of his work and his sensibility was in his capacity to change very very rapidly back and forth, maybe even constantly back and forth, from a man to a woman, but still one doesn't really quite know what to make of that, just as you don't really know what to make of his having assumed the name 'Rrose'; Rrose Selavy might easily have been the name of a transvestite or a whore around St. Denis. He said he liked the name Rose because it was the most trivial name he could find, and it also connected up in his mind with the idea of being Jewish, or at least he says that the idea of changing his name had started with the idea of changing it to a Jewish name, but then what he ended up with was Rose, and in any case there's a rootlessness, an availability, he's as though he were a one-man diaspora. His work is a diaspora in the way it contantly moves from one thing to another, a kind of meander with no straight lines and nothing ever that implies a center. Being centerless is a very important thing to be. It's one of the things that a certain kind of survival is all about, the kind of survival that's threatened by orthodoxies, or by belonging to things, or by believing in things one hundred percent. But the feelings you have about nomadism aren't of course all that simple. Nomadism is a response to all sorts of threats, or surrounded by all sorts of threats, and there are things for which the nomad is himself a threat. A nomad has no fear of departure, but he never escapes from other people's fear of departure since it's in all the situations that he's always entering and leaving behind. I watch a nomad set-

ting out and that's frightening for me, I find his courage frightening. That's just how different he is. The ways we compare ourselves to a nomad are just that poignant.

There was even a kind of diffidence in my attitude to Duchamp when I first began to get to know him, not a diffidence with respect to the person, a diffidence more with respect to his work. But now I can see how that diffidence was a way of avoiding the problems that would have had to arise if I hadn't been diffident. How could you begin to build a house on a rock-slide, set up some sort of construction on a bog of quicksand, set up the foundations of something on an emptiness? And that's one of the things that Duchamp represents, an exploration of all the kinds of emptiness, an exploration of the void, a measuring of the void; that was somehow the place, or the non-place, in which he'd elected to live; it's not as though he had established some sort of citadel on a foundation of bedrock so that others might then come along and set to work on completing its turrets, it's not that sort of thing at all. Trying to use Duchamp as the basis of something, or seeing him as a fundamental reference point, requires an enormous effort and I avoided a perception of the difficulty of the task by letting it flip-flop into the feeling that everything I had to understand was already understood. Of course that wasn't true at all. I think back to the way I ignored his offer to sell me a copy of the *Box in a Valise*. I'd expressed an interest in it, and he gave me a note to take to the people he'd commissioned to assemble these boxes for him, and they were to let me have one for five hundred dollars. But I just never went to see them. That wasn't an easy amount of money to spend at the time, but I'm sure I could have gotten it together if I'd wanted to. Something

more than that was involved in this decision, or non-decision, for which I've never been able to give myself any really thorough explanation. It's as though I didn't want that sort of relationship to his work. How can you apply an idea of ownership to a box full of *flatus vocis* and a couple of photographs? The whole thing was so different from the very idea of the work of art that it seemed to imply that possessing it couldn't really have anything to do with what it was all about. So, on the one hand, the idea of having this thing had an appeal for me, and on the other hand it invited me to think of it as something that simply couldn't fit into a class of possible objects of desire. It's as though I were asking myself what sort of meaning could be attached to owning a Duchamp and having one of his works in your house on a table in a hallway or sitting on a shelf. I mean, how could you go out and buy one of the copies he made of the *Bicycle Wheel*? That seems such a silly thing to go out and do. First of all, you should try to come to an understanding of whatever it is that this *Bicycle Wheel* can possibly mean. I find this object tremendously intriguing and I am quite unusually fond of it, but it's not the sort of thing I'd ever think it possible or sensible to own; it's not the kind of thing that can inspire that kind of fetishism. For me, it's always as though the two of us are living in the same house and he's off in his room making the *Bicycle Wheel*, and okay so now he has made it and he has shown it to me, and you realize how odd a thing that is for somebody you share a house with to have decided to make, but what sort of a roommate would you have to be to decide that you wanted to buy it from him? You'd be much more likely to decide that your own way of passing your time was just as fertile as his. Maybe you'd think that this *Bicycle Wheel* was just a very bizarre way of killing a few dull moments and didn't

really mean anything at all. And maybe the day after tomorrow you'd both forget about the *Bicycle Wheel* and do an automobile wheel together. I have a replica, if you like, of the *Bottle Dryer*, but it never even occurred to me to have him sign it the way Rauschenberg did, and what it cost was the price of a bottle dryer. I bought it in Paris at Bazar de l'Hotel de Ville, which is where Duchamp bought the original in the first place, the one I have is a ring higher or a ring lower, but what sort of difference is that supposed to make, it's exactly the same thing. And it's the same thing again with the urinal. If you want to look at Duchamp's urinal, the *Fountain*, if you need to have one around to be able to think about it better, all you have to do is go to a plumbing goods store and buy a urinal, why should a urinal be something you go out and spend ten thousand dollars for? You could do that with all of the Ready-mades, except maybe the *Comb*, since that's a kind of comb you can't find any more, and so you can do without it. And should I really want to have a comb, or a coat rack nailed to the floor, or a hat rack hanging from a string so that I could point it out to people and say 'That's Duchamp'? Anybody who owns a Duchamp, well, that's his own business, but any suggestion that I myself could give him about what to do with it would be fairly vulgar. A Duchamp is such a stupid thing to hoard into a collection or a treasure trove and maybe even have to insure it against fire and possible theft, I mean imagine insuring a Ready-made against theft or taking it to a bank vault for storage during your summer vacations. Possessing Duchamp is something you have to go about in ways that have nothing to do with the possession of any of the objects that he made, it's an entirely different thing. Saying that may be my own particular brand of intellectual terrorism, but that's the way I see

things. Taking possession of Duchamp is something you only manage if you pass a whole life at working on Duchamp, or rather working *with* Duchamp, electing him as a kind of collaborator and thinking of him as the point you're starting from, and trying then to understand the nature of the limits, or rather, the range of his thought, that and the nature of the currents of induction that can exist between one artist and another. What he gives you is a certain kind of confidence, or the confidence to do certain kinds of things. Take the absurdity of his nomenclatures, for example—'love gasoline,' 'oculist witnesses,' a 'cemetary of uniforms and liveries,' 'standard stoppages'; he makes it clear that things like that can be done. He teaches that lesson much better than Lewis Carroll ever could. Carroll is finally rather minor, he needed all sorts of excuses for absurdity, he could only allow himself to get away with that by pretending that he wanted to be amusing for a little girl; he never really faced up to the absurdity that lived inside of him, just as he never really faced up to the fairly wierd sexuality of taking photos of little girls in the nude. Duchamp never needed excuses for anything and that's part of why his absurdities are never infantile; they're never contaminated with psychology and psychological explanations, they're about what the mind can learn about itself when it learns that one of the things it can do is to be totally arbitrary. Involving yourself in that kind of undertaking is one of the things that Duchamp can give you the courage to do, you learn to charge things with meanings that they'd never had before, you learn to charge words with meanings that they'd never had before, you learn to turn them into those kinds of words that he calls 'terms that explode' and that mean and imply much more than any dictionary definition could ever possibly

make you suspect. He shows you how to be a cartographer writing hypothetical names on hypothetical maps that take you to places where you can keep from going mad; or, rather, it's precisely the other way around, they lead you to the madness that you know you ought to be looking for, but they get you there without your having to throw yourself off the edge of some mental Etna into an abyss that you'll never again be able to climb back out of. And so there's nothing really fanatical in saying that the possession of an object by Duchamp wasn't a way in which I could legitimize the contact that I needed to have with him. Buying that box, as I look back on it now, would have been a renunciation: it would have gotten me off onto one of the wrong tracks. It would have taken me a bit too far in the pretence of already having understood him. I had to see that the mysteries he'd produced and turned into relics and left behind him were much less important than the mysteries he could still produce. There was a fear there, but more than the fear of departure it was the fear of standing still.

After all, Duchamp's was the very truest kind of nomadism, which is to say it was an entirely mental nomadism. Otherwise he was just back and forth from Europe to New York and would go to Spain in the summers, once I think he was in Argentina, physically he just did the kind of travelling that everybody does, even though the times he did it in were more adventurous since, at least at the beginning, he was travelling on ships. But he was never in Africa, he was never in India, he never saw Japan, he never visited China, he didn't have that kind of curiosity. For certain kinds of minds, the idea of moving through space doesn't have a great deal of appeal. It's a

question of living so intensely in imagination that it's as though you had already been everywhere. And that's still another way of being content with as little as possible, which is another part of what being a nomad is all about. I saw an interview not too long ago with Alberto Moravia, the novelist, and they asked him what travelling meant for him. He said that travelling meant that he had to have an extra pair of pants, a couple of sweaters, one of them light and the other sleeveless, a couple of shirts that don't show dirt too easily, and a pair of loafers and a hat. At first, that can seem a stupid kind of answer or the answer to some other question, but, really, it couldn't be better. What makes it beautiful is its realism. And what were the things that Duchamp travelled with? Practically nothing. Maybe his cigars. It's difficult to imagine that he ever found himself in a situation where he wanted a cigar and didn't have one with him. You don't imagine though that he ever needed any particular book. He'd read Pavlovsky once and that was the end of it. He used that book by Demeny, but you certainly can't imagine his feeling like carrying it around from one place to another. He didn't have those kinds of needs. There's a story of his once going to visit someone in the country for a weekend and arriving with only a toothbrush and wearing two shirts. Duchamp's essential baggage consisted maybe of his friends. He travelled from *Bottle Dryer* to *Enfant Phare* and from there to *Monte Carlo Bond*, and from there to *Large Glass*, and he always had the company of people like Man Ray, or earlier it was Picabia. People who were somehow more shrewd than he was, more inured, people more involved in the outside world. You can imagine Picabia as somebody always insisting to him that there was someplace to go, Picabia driving the car on the *route Jura-Paris*, an evening of

dancing organized by Francis Picabia. In the *Notes* that were just published in Paris, there's one that's somehow similar to a comment on the need to travel with nothing more than a hat and a second pair of socks: all it says is *allégorie d'oublie*. That seems to me to sum up the whole idea of the sort of baggage you carry around with you as you move from one place of the mind to the next. And the association may seem odd, but the idea of an allegory of forgetfulness also connects up for me to the idea of the *retard*. The *Large Glass* as a *retard en verre*. A delay. A delay in glass. Which could mean just about anything. A delay is always a delay in something that's supposed to be on time, a delay in something that's supposed to be arriving or a delay in something that ought to be in departure, and that's about travel once again. In French, a woman who's waiting for her period and it doesn't come says she's having a *retard*. A person with serious mental difficulties is referred to as retarded. *Arrieré*. Somebody who's in back of something else, or who gets somewhere after somebody else. The idea of a *retard* always implies some sort of mental time table, something that comes first and something that gets there later, and why should the Bride be a *retard?* You can say anything at all that you want to about that, from the vulgarity of imagining that the Bride is late with a menstruation, even though that's not very likely since she's never even been reached by the Splashes, and I wouldn't want to attribute Duchamp with a vulgarity that might be considered unexpected. But then again, that sort of thing could come to mind if you think about his affection for Roussel's puns and plays on words where the *double entendre* is always about somebody's taking it up the ass or something like that, and what about *Tu'm*, which always seemed to me to mean *tu m'emmerde*, and that's the

explanation that's given by Schwarz as well. So anything at all is possible. Anybody who can refer to his writings as a series of *texticules* would be perfectly capable as well of a menstrual sense of the word *retard*. That wouldn't really surprise me, the work is so odd in any case, such a series of meanders and paraphrases, and all of it incredibly lunar in the kinds of facts it deals with, things just barely touched upon or ever so vaguely hinted. But the only thing you can be in any way certain of is that the *retard* is an idea that comes from someone who's very much concerned with the idea of working in time, with working on the idea of time. And perhaps this *retard* is a question of the general delay of the whole world that existed around him, the delay of the world, the retardedness of the world when it's compared to the kinds of things he was interested in. The delay would be all the rest, not the Bride and not what's on the *Glass*, but the infinite possibilities of the entirely ordinary world that's behind it as a background. Think of it as standing in front of any window in the world, in front of every window in the world, or in the middle of any possible landscape. The events and characters on the *Glass* can nomadize through all these delays because the *Glass* itself is transparent. And the idea of a delay is as *inframince* as you can get, it's *inframince* to the nth degree. What's a delay of five minutes? It's like his notes about the heat left by a body on a chair, an innuendo, a yawn, any of those 'weak energies' that interested him. An allegory of forgetfulness. Which is where we started from but I still don't have any real understanding of what leads one association into another; but how else does it make sense to deal with these boxes of fragments he left us with? These boxes of fragments that pull you into this world of the *inframince*, that make you one of the inhabitants of the *inframince*, one of the inhabitants of

the *inframince* whom he defined as *fainéants*. How else is a fainéant to think? That's the way he thought of himself, a fainéant or a lotus-eater involved with a pre-Socratic wisdom, and his wisdom was a question of knowing that there was nothing for him to do. He remarked that there are no solutions because there aren't any problems. Which is something else you can't really be clear about, and you don't perceive the way in which he was clear about it. At one point I reacted to that with a poem that said that having a problem is the only solution, or that the real problem is to resolve the problems, or that there aren't any problems because there are only really solutions. It's not important and I don't remember, it's just that this was one of the thoughts he had that at a certain time I felt I had to deal with, and it seemed he said too much when what he really meant, most probably, is that there's no point in thinking about the problem of death, as though to say that death itself doesn't exist. The phrase chiseled onto his tombstone says, 'In any case, it's always the others who die.' And that's something else you find in these *Notes*, there's the phrase, and beside it he has written and circled the word 'epitaph,' as though that were just another mumbling about the *inframince*. His coolness was tremendously ingenuous, and on the other hand you can't help thinking that this ingenuousness could be the reflection of a tremendous wisdom. Everything he said was too simple and too apolitical, but all of that extreme simplicity was also extremely fascinating and you can't get away from seeing how completely he sustained that point of view for all of his life. And any energy that a person can live on for all of a life is something you can't really throw away or denigrate, or value too lightly. So perhaps it was true for him that there were no such things as problems and solu-

tions. Personally, that's a difficult thing for me to believe, it's difficult for me to see the totality of his own belief in it, it's difficult to see how that explains all of the various articulations of his life. The very fact that there was a moment in his life when he decided that living among painters was something he no longer wanted to do, well, how can that be anything other than the perception of some kind of problem, how can that be anything other than shaping your actions in terms of the perception of some sort of solution? His whole life is an artfully constructed enigma, it's an enigma in the context of art, why he did this and why he did that, why he wrote what he did in the way that he did it, why everything had to be so secretive. A work like *With Hidden Noise* isn't just something isolated in his oeuvre, but sums up something about all of it. And it's such an odd kind of secrecy to be involved with: an object containing some other object that's unknown to him since it was chosen and hidden from him by someone else. And there's more to that, I think, than simply saying that the work attests to his willingness to accept other people's secrets and their right to having them. He's incredibly complicated. There's that mind-twister he wrote that I like so much: *'Croyant m'entendre écouter, il m'a demandé de vous demander si vous saviez qu'il savait que je l'avais vu regarder celui à qui j'ai repondu que je ne repondais du rien'* —thinking to understand me to be listening, he asked me to ask you if you knew that he knew that I'd seen him glance at the man to whom I'd answered that I'd answer for nothing. There's a kind of vertigo in that, both a madness and a desire to drive a reader or a listener mad, it's like the verbal and psychological and behavioural puzzles that Laing collected in that book of his called *Knots*. But as soon as you say a thing like that, you have to wonder if you have any

right to say it. Which is the way you feel about all of the references that you bring to bear on Duchamp, and he seems to invite you to bring so many references to bear on him. But what can be objective in that except the objectivity of your own personal association networks? What can possibly give you the right to make an association between this grand old man of a turn-of-the-century avant-garde and the studies of a modern phenomenological anti-psychiatrist? Is that a measure of the power of Duchamp or is it the measure of the addle-mindedness of somebody who's thinking about Duchamp? But it's hard to avoid the idea that he had a sensitivity to problems that other people weren't to find important until far later. That 'delay' again. And if there's any place where it makes sense to say, 'If you can't be just, be arbitrary,' that place is when you're looking at the works and words of Marcel Duchamp.

He covers an incredible amount of territory, just as he covers an incredibly wide range of tones. Some of his plays on words and arrangements of alphabets are almost embarrassing. They're almost a kind of whorehouse wit, or the sorts of things that get passed around a classroom by the kids who've been made to sit in the last row of desks. What do you say about somebody who could keep a box under his bed full of pages and pages of phonetic puns like LMAP, or LHIEOPI, or MOAGBZDDSOSLARNU. LHOOQ was really the most innocent one of the lot. Things like that can make you wake up in the middle of the night and wonder if your attempts to look for a philosophy in this man aren't after all a little delirious. Certainly, it's fairly difficult to limit your speculations to what he declared as an interest in phonetics as a source of internal rhymes. And how safe is the ground if you try to prove that the rather

dubious content of these little inventions is itself a proof that his love of acrostics and enigma and for playing with the French pronunciation of the alphabet went just that far? Or that this was simply the sort of thing that he did rather than, say, open a book by chance and make some use of the first thing that appeared before his eyes? If playing with the way the French pronounce the alphabet is supposed to be a bottomless source of odd juxtapositions and curious surprises, how come most of these things he did are so curiously one-sided? If he was an expert in enigmas and a maker of puzzles, you have to admit that some of these puzzles don't always come off, and that they often lack a certain elegance that you'd like to be able to find in them. But what's odd is that a person who could indulge himself in such trivial forms of personal reminiscence or personal fantasy could also make constructions where words and objects are disconcertingly cold and incredibly distant from anything intimate, things, for example, like hanging up a snow shovel and calling it *In Advance of the Broken Arm*. On the one hand, he can lead you into speculations on things that were intimate and sexual in his life, which is a part of the reaction you have to works like *Objet Dard* or the *Coin de Chasteté* or to certain notes about the more glorious sexual potency of his youth; and then, on the other hand, he can be absolutely crystalline and totally abstract in a world of the totally meaningless. That dream about his constantly fading in and out from one sex to the other may really have been a perception of his ability to work with so many different valences of experience and at so many different levels of emotion, including non-emotion. But saying that could still be a way of trying to cover something up and of avoiding some of the problems he presents. How really do you deal with

someone who could author the puzzle LMAP? What sort of use, finally, does he allow you to make of him? What sort of way does he allow you to think that his name has to be made to last? Picasso is supposed to last because his name is attached to the Picasso Museum. In France now they talk about the Mitterand Effect. There's a Nansen Passport, and a Russell Tribunal, and Bunsen gave his name to the Bunsen Burner. What's Duchamp's name supposed to be attached to? Maybe somebody will write a book about Duchamp and the French pronunciation of the alphabet. 'Duchamp and Puzzles,' 'Duchamp and Acrostics,' 'Duchamp and the Sphinx,' 'Duchamp and Whorehouse Wit.' These are all titles that we can offer for possible Master's theses to be written in Paris at the Academy of Fine Arts. Duchamp is a constant source of drift; what you do with his work is simply to drift your way through it. Maybe Duchamp will become a passport too. Or what about defining the Duchamp Effect? The effect we're defining by drifting this way through everything he thought and wrote, the effect we're defining by the way he confuses us. And this confusion is important. It's important because it's one of the natural responses to Duchamp that's always suppressed. Confusion is something that's never admitted to in any of the critical texts that you see written about Duchamp, there's no perplexity there at all, everything is presented as clear and abstract and limpid, the critics simply don't admit to having experienced this Duchamp Effect that we're talking about; it's a duty really to be confused by Duchamp: he was often involved in creating something close to nonsense, and what's one really supposed to do with nonsense if not be perplexed by it? That's certainly much more sensible that dedicating all of your time to trying to explain it.

So isn't it funny that he should have been able to remark to Cabanne, *'J'étais normal au plus haut degré'?* Cabanne had been asking him about the role of women in his life, but the phrase is still surprising, especially when he follows it by saying that his attitudes at the time were anti-social. He's really the blithest spirit of them all. There's another place where he says that the *Glass* was a sum or collection of experiences or experiments, and that he'd gotten involved in making these experiments *'sans avoir d'idée.'* That's quite a concept of normalcy. And he thought of the *Green Box* as though he'd made a kind of album. The *Glass* wasn't to be 'looked at' in any aesthetic sense, and so it had to be accompanied by a series of notes and reflections and calculations that people were supposed to be able to consult while viewing it. That was part of his way of denying whatever there was of something 'retinal' still left in the *Glass*, and he insisted that all of this was extremely logical. An album to facilitate the study of a series of experiments that he's performed 'without having any ideas.' And if he was willing to go on record with a statement like that, there's nothing that allows us to remark that, well, he may have said it, but it really doesn't make a difference. I mean, if he said it, it must be true. Freud can't be allowed to allow us to explain absolutely everything away, and if Duchamp said he did his *Glass* without having ideas, that doesn't mean that we're licensed to unleash all of our hypotheses about the nature and function of the unconscious. It should mean that we might try to find out what it meant for him to say that he did something without having ideas; if he used the word 'ideas' he certainly had a definition for it, and that definition is something that might very well hold a lesson for us. I may be perplexed by a purely phonetic definition of some of his

alphabetical puzzles, but what Marcel had to say about himself is usually a great deal more interesting and useful for me than anything the critics have ever had to say about him, and he was very much aware of being 'literary,' so we ought to be able to imagine that what he had to say about himself makes sense. When he thought of putting *même* at the end of the title of the *Large Glass* as a game where there's a kind of floating adverb without any precise reference, well, why not say that that's a possible example of what it means to work without ideas? What he was interested in was the feeling state that an adverb brings with it, a kind of feeling state you get to by using the adverb nonsensically, a kind of feeling state that's ordinarily obscured when you feel the meaning of the adverb rather than its function. That's much more seductive for me, more seductive and more stimulating than trying, say, to eliminate that game by pointing out that *même* is a homophone for *m'aime*. That kind of explanation doesn't give me any ideas for experiments that I could perform on my own; that's a kind of explanation that tries to go deep, but I prefer to stick to Marcel's own sense of superficialities; the idea that *même* is a pure and meaningless adverbial function hooks up for me with the way he could call the *Glass* a *retard*. In both cases, it's a question of relationships in time; the very function of the adverb is to slow down comprehension, it complicates comprehension with ideas of moods and modes, adverbs aren't rapid-fire specifications of physical qualities the way adjectives are. That *même* is a kind of underlining, it's a kind of drone, a drone that gives almost a numinosity to the phrase that precedes it. Duchamp's own way of dealing with that word is simply a great deal more elegant than any of the other explanations that people have tried to give of it. Everything he did was so precise, he always moved with

a very precise knowledge of this spider-like web he was weaving. And even though it can seem to be a web of delirium, he was always picking and choosing, and looking at things very attentively. And he'd settle on things and claim them as his own when he perceived the possibility of filling them with some very special atmosphere. Perhaps we were overlooking a question of atmosphere when we were talking about his alphabetical puzzles. Maybe we should think about the tone of reading the letters, which is much more solemn than the words into which they transliterate. Hearing JAY BAY ZAY DAY DAY ESS is very different from hearing *j'ai baisé des deésses*. Maybe you can only understand these things once, or you can only understand them when you think back to the effort you had to make to decipher them the first time around. That effort is as though rewarded by a style of aulic diction, and what you end up with is a juxtaposition of a trivial message and an oracular voice. Filling things with an atmosphere of something medianic and oracular and absolutely overcharged with meaning is what he was always up to doing, and that, after all, is what art is all about, or, at any rate, what modern art is all about. You take just about anything at all and fill it with all the meaning you can give it, all the entirely personal and entirely arbitrary meanings it can possibly hold, all the mystery, all the enigma it can hold. That's one of the most fundamental lessons Duchamp had to teach us. How else can you deal with his Ready-mades? How else could you possibly define them? You take this thing and you say that this this is that, and you make an abracadabra sound or a sound like 'Verily I say unto you,' and a urinal is suddenly a fountain. This way of attributing meanings to things is really an extension of an act of perception. And that remains the case even when your

hypotheses have to be a little less clear about the kind of relationship that may have existed between his world of words and notes and the world of the objects he was making. You can ask yourself if he did the *Green Box* before he did the *Glass*, or if he did the *Glass* before he did the *Box*. Was he making notes about a Glider because he was making one, or was he making one because he found himself making notes about one? Both of these possibilities are a part of the poetics he was involved in, since a kind of interchange was always going on, which is to say that his mind was always involved in flashing off flashes about things that had already themselves been flashes in the first place. He was always working back and forth from the word to the image and then from the image to the word and then from the word to the image again. And that's very important. His universe of words and his universe of images were always cross-fertilizing one another, always attaching back and forth to one another, he was never involved at all in talking his work into existence, which is what so many people get involved in doing when they begin to feel that the important thing in a work is less the visual work than the universe of discourse to which it attempts to refer. There was never that kind of separateness between word and image for Duchamp. He saw them related, and he elevated that relationship into a system, and it's this system that allowed him to know that he was dealing with things that were actually acts of perception. Other people might have thought that his urinal-turned-fountain was a madness, but he knew for himself that it wasn't, and here we are today seventy years later and it's something that all of us are still talking about. And even if it gets taken as a gesture and seems somehow funny—it even seems funny to me—the truth of that object is in

seeing it as a kind of challenge, as a kind of messianic challenge. He was perfectly sure of himself and he was perfectly and entirely convinced that this toilet was the most perfect and precise formulation of exactly what he wanted to say. It was an act of expression that summed up everything he wanted to express in that particular moment, which was a moment in which he *saw* it as a fountain; it wasn't by any means simply a joke. And even though he sometimes tended to minimize his work, he also had that other tendency to make it clear that his life was always full of calculations and observations and a very great love of spiritual experimentation. His works were always at the center of a nexus of associations; they're the substance of a whole way of thought that existed all around the edges of non- sense, or, rather, as he put it, all around the edges of 'anti-sense.' That nonsense or anti-sense was part of an attempt to put humor and poetry into his work, but it also connects to the whole idea of the fourth dimension, which was always a much more literary rather than scientific hypothesis for him. And he had that curious way of saying that all of these literary preoccupations were of interest only from a point of view that he described as *très léger*.

Duchamp, really, was much less scientific than pseudo-scientific, and if you put his work in front of just some ordinary boring physicist who's really into science, all the physicist will be able to do is to laugh at it or to go off and have some sort of awful dream. Duchamp's use of science and of scientific concepts is very much like his use of puns and plays on words. He could use the idea of two lines that intersect to form a point, just as he could use the idea of the encounter of the letters 't' and 'r' to make 'tr,'

which became something significant for him in the non-sensical assonance in the title *Jeune homme triste dans un train*. Two lines that cross to make a point become a justification for a phantasy where three-dimensional space is an intersection of a pair of four-dimensional spaces. He'd start out from scientific fact and scientific thinking as a prelude for thoughts that were surprising and disturbing and that simply give pause and call the mind to a halt; and that might even be said of the interest in scientific perspective that he'd already taken to an extreme with his *Chocolate Grinders*. Or look at his explanation of doing *The Bride Stripped Bare by Her Bachelors, Even* on glass; he says that he simply happened to have been using a piece of glass as a palette and liked the look of the colors from the back of it and thought that painting on glass would be an ideal way to preserve them. You can't be much more pseudo-scientific and *très léger* than that, at least in the sense that the idea didn't at all work out; rather than preserve his colors, the glass accelerated their disintegration. Duchamp himself has the butterfly quality that he ascribed to Apollinaire, and he possessed it to a greater degree; he had the capability of flitting from this to that for reasons that finally aren't reasons at all, an ability to do something simply because he felt like it; he could decide to make a work on glass because he liked the look of the back of a glass palette, he was light enough to be able to call the *Glass* a *retard* because it seemed a disconcerting and poetic thing to do, there's something aerial in arbitrarily adding the word *même* to the title of the *Glass* as a way of toying with the feeling states of meaningless adverbs. And it's important too that this lightness went even to the point of playing these games with the titles of works that he surely had to recognize as important. *Jeune homme triste dans un train*

was the earliest version of his *Nude Descending a Staircase.* There's a very beautiful instinctive ingenuousness in Duchamp, and all of his little discoveries have the exactitude not of science, but of 'monograms.' Kant talks of 'monograms' as a painter's momentary sense of having found an ideal of sensibility — 'a pattern afloat in the midst of diverse experiences, an incommunicable phantom in the judgements of painters. An inimitable model of possible empirical intuitions with no discernible or definable rule.' That's virtually a definition of a Ready-made, and I'm sure Duchamp would have been quite content to hear a thing like that applied to him. I think that making monograms is what I too am mainly involved in, and it's just that the work I do has to be different from everything Duchamp did because I exist in a different world, and at a different moment in the history of the media of communication. I'm surrounded by newspapers, surrounded by television screens; and abstract ideas aren't very important for me; so instead of using found objects like a Duchampian clothes rack or a hatrack, I make use of found information, found photographs, found phrases, fragments of dreams and phantasies and daily life, stories told by the children I happen to live with, and all of that is what I put together in the way he put together the assonance of two words that begin with 'tr' in his hovering around *triste* and *train.* The kind of encounter with reality that's typical of the experience we live through today makes it necessary to do things that are different and more complex, or at least that's true for me. There are whole galaxies of juxtapositions I feel I have to deal with, but I'm dealing with them in ways that are comforted by the precedent of Duchamp; it's as though I do what I do and then look at what he did and the message I get back is that what I'm doing is okay, even

though I have to be much more involved than he ever felt it necessary to be. The difference, you could say, is a question of personalities, but I also think it's more than that. Being a Duchamp today wouldn't really be possible; he was special and unique and everything that happens after him has to take him into consideration, but the same thing will never be able to happen again, and wouldn't make sense if it did. It's odd that it ever happened in the first place, and you certainly can't explain him away with art history; you can't say he up and decided to do the *Monte Carlo Bond* because Picasso or Cézanne had previously done something else. He did the *Monte Carlo Bond* because he was sick of living in Picabia's country house with a stupid woman he happened to be married to and his mind was odd enough to offer him the solution to all of his problems in a vision of being able to live off a system for winning at roulette. People now talk about the *Monte Carlo Bond* as a brilliant work of art but they forget that it wasn't supposed to be art at all; it was just a part of financing a trip to the casino. There's another example of involvements that are *très léger*, just the way he goes off to the bathroom at the movies and pisses in the urinal and it crosses his mind that a urinal is really a fountain, it's so obviously a fountain, and suddenly that's another little fulguration, another monogram to capture, and those are the things on which he based his work. He had these moments when things had a sudden clarity, and then he'd live on them for a decade; and, for me, that's the kind of experience on which I try to base my own works; those are the kinds of procedures that my works are always about. I make collections of little epiphanies that finally get together to form some sort of object, and it's as though every one of them bears a stamp that says 'Large Glass,' or 'Mariée,' a sort of

seal of approval for representing a basic kind of sensibility. This is what Duchamp is all about for me, and you never get away from the irony of it; there's an air of something slightly funny about it; when you look at that sort of thing you always want to smile. What I've learned from Duchamp is that you have to accept everything, the silliest kind of juxtaposition, the absurdest kind of rhyme. He has an openness that you don't really find in an awful lot of artists. Think about his brother, who dedicated a life to sculpting horses, and they're incredibly beautiful horses, but then there's a point, if you're an artist, when you look at one of these horses and ask yourself if thinking about horses and trying to sculpt them is something you'd want to pass the entirety of a life at doing. That's not the kind of thing that gives you any energy, or that's constantly able to call you into question and to force your values into a state of crisis; what forces you into crisis is a man who's capable of lifting one idea here, another there, then some minor notion from Roussel, then some inspiration out of nowhere, somebody who follows his whims. And that's the lesson he left us with; it's not at all that he dedicated himself to making beautiful pictures of horses so that now somebody else can make beautiful pictures of Deer Beetles; it's not that sort of thing at all. Duchamp gives authorization to do whatever you want, anything at all, just so long as you really like it, just so long as it really makes sense to you. He allows you to work on just that kind of desire, just that kind of libido, he teaches you the fertility of trying to work on the basis of living through these odd kinds of experience, which is an entirely different thing from the pleasure of living the ordinary facts of daily existence. His name is attached to the invention of an incredible number of passports that allow you to

visit everything that's unusual, passports for visiting the territories of everything that's unknown. And these passports are all the little formulas to which he gave a transient substance by writing them down on odds and ends and scraps of paper, and sometimes sticking them into titles of works of art.

People ask me, for example, about the way things are organized in the space of my paintings, and all I can say is that now we're sitting down over here, but if the telephone rings I have to get up and go over there, and at one and the same time I'm looking at either this or that, and something said by the girl who works as my assistant comes back across my mind. What I'm involved with is a discourse that planes through a dozen different spaces all at once and with a hundred different subjects in twenty different dimensions and all happening all at once, and I float in it in a way that keeps me from having it all drive me mad. I'm not mad at all. My life is in reasonable order, and my checks don't bounce, there are things I have to be responsible for and I am responsible for them; unlike Duchamp I've got this *maison de campagne* and I don't have any reason to feel that I shouldn't. Everything is so different now, there's no need, no reason to be detached the way he was, he was sufficiently detached for all of us. Now you can have a *maison de campagne*, and an *automobile*, and a *femme* as well, and you can still make use of Duchamp all the same. It doesn't make any difference that he could never have dealt with the idea of a *maison de campagne* or that if he'd had one maybe he'd never have gotten involved in inventing any of the objects and ways of thinking that he passed his life at inventing. The lesson, then, is simply *Etant donné Marcel Duchamp.*

Yesterday, for example, towards the end of the afternoon, I chanced across a stupid photo of somebody on a bicycle, somebody who'd just won the *Giro d'Italia*, and I said, 'Ah, yes, the *Bicycle Wheel*,' and stuck it into the box I was working on. But the point here isn't that that was in any way a reference to Duchamp, it's just that it was rather as though I found myself saying that maybe if one day I were to do the absurdest thing in the world. . . . And what really is that *Bicycle Wheel* all about? Do you do a thing like that because it's pretty when you watch it turn in the light of a hotel room? It doesn't mean anything. It's some sort of a game a child could play. And at one and the same time, it can also be an image of the essence of the universe. It's an image of anything and everything, and what Duchamp did was to make it possible for anything to mean anything and everything. He made it possible for anything on one level to touch everything on every other level, and that's quite a trick to have pulled off. Who else can you thank for having done a thing like that? Picasso and his seven female nudes a day, who wants to make seven female nudes a day, three after breakfast and four after lunch, what am I supposed to learn from that? There's nothing at all that I can feel that Picasso has given me some miraculous authorization to do, and Duchamp on the other hand gives me authorization to pretend that I myself am Duchamp. Every day, just before noon, you can look in the mirror and there's a voice from behind the glass that asks you 'Have you been Duchamp this morning?' and you have to answer either yes or no. And every day now, I can say yes, at least a little bit, and it's not at all as though I spend my life looking through the books about him and by him, and I don't even know how to play chess at all, it's rather that there's this sense of lightness, this sense of irresponsibility, and these are really

the things that are fundamental in his work, he doesn't present himself as any kind of Titan, you never see him sitting on the pot with his head on his hand like the *Thinker* by Rodin, he's not that kind of image at all. His image is that butterfly, and he could flit and flutter, twisting and turning as it pleased him from here to there and he'd settle wherever he felt like it; and, sure, when he settled on an idea he was capable of sticking with it for a decade, but there was this butterfly-like quality in the choices that he made, there was a butterfly-like quality in the way he went about making them. *Très léger.*

Marcel Duchamp, circa 1964. Photo: Baruchello.

One of the premises of what we're doing is that we don't in any way want to compete with the kinds of comments that the critics seem to feel that they have to make about Duchamp. And when the subject came up in *How to Imagine*, it was probably a mistake to suggest that it's simply still too early for criticism to make sense of Duchamp. The incompatibility between Duchamp and critical analysis has something to do with the very nature of his work, and that's not a situation that time is going to change. Think, for example, about this cloud of words that hovers around the work of Duchamp. They're very special words and they function differently from any words that had been connected to painting ever before. The words that surrounded the work of Giotto, for example, were words that he shared with the entirety of the society he lived in and worked for; he was working on the basis of all the words that explain his iconographic tradition, and his paintings were illustrations, even though they were new and different illustrations, of stories that everybody knew. You always know what the painting is 'about' since you understand what events it's referring to. And even though we may not know the stories that surrounded those paintings of bulls in the caves of Lascaux, we can still be sure that the people there were likewise in the habit of sharing them by talking about them, or maybe by dancing in front of them. The idea that paintings can be only visual is very new, and even that is less an achievable goal than once again a part of a verbal myth that's shared by people who don't want to believe in myth. But with Duchamp, things are different. He saw the need for a myth, but he also saw that there were no longer any current or commonly available myths to illustrate, and he began to make a myth of his own. When he started to work, it was only a decade or so before

the First World War, and the world that people had known in the nineteenth century was going off its tracks and no longer making the kind of sense that it had made before. Duchamp was living through an extended *fin de siècle*, and in seeing the failure or demise of a culture that no longer offered anything worth talking about he decided to descend to the lowest, frailest, most senseless, and most arbitrary engagements of the psyche—the levels that he called the *inframince* and understood as the most basic or mysterious levels of any possible discourse. This was the basis on which he thought it might be feasible to begin to think again, and to begin to reconstruct a possible mental world. The enigmas of the *inframince* were where he thought to make a place in which he might like to live, a myth that would give him the energies that make it possible to have the will to live. And this was a myth that he couldn't and didn't share with anybody since it was something he was inventing entirely on his own. One of the feelings you have about Duchamp is that he was always alone; everything we know about his life communicates a sense of a finely calibrated solitude. And one of the things to infer from his notion of 'elementary parallelisms' is that the only way to react to a world—to his world—is to create another world, a world of your own, a world that runs alongside of his without really touching it, a world that has ways of rhyming as his world has ways of rhyming, but that remains essentially separate. So there's simply no place for the idea of exegesis. Duchamp seems first of all a stimulus for undertaking similar adventures, similarly enigmatic, but personal and different, and the idea that criticism should 'clarify' his work is without any real sense. Duchamp requires disciples or collaborators, rather than commentators.

If we want to face up to the problem of criticism, we also have to think about the way Duchamp related to critical ideas, and I don't think he related to critical ideas at all. He didn't have any *intentions* that took account of criticism. If I imagine his state of mind while putting together the *Green Box*, I don't at all see him as involved with gestures or signals that take even the slightest consideration of the possible reactions of any possible critic. He simply wasn't concerned with that, as far as I can see. Ideas like that just didn't pass through his field of thought. And partly, too, because what we think of as criticism simply didn't exist at the time; critics didn't exist. Apollinaire, and Baudelaire before him, both wrote about art, but you'd hardly want to call either of them a critic; there were only poets and writers who happened from time to time to write about art too. Duchamp was thinking about exciting reactions at some entirely different level. And, okay, there was Breton, and I don't suppose that Duchamp was entirely indifferent to what Breton had to say about him, but he certainly behaved differently from all the other people in whom Breton took an interest. Everybody else was always making a big fuss around him and taking him very seriously, and Duchamp, on the other hand, took fairly little notice of him. He never got involved in Breton's concept of a group, and he never had any interest in any of Breton's excommunications or in any of the positions he decided to do battle for. Even though his friends were some of the most brilliant and disconcerting minds of their times — people, again, like Apollinaire and Breton — Duchamp was always off on his own, and he preferred to sit somewhere and play chess or go off to Monte Carlo and try out his schemes for breaking the bank. None of the things he did were ever thought of as offerings to the altar of other

people's comments. His images, objects, and gestures, and all the words that surrounded them were open to every possible use, but there was never any wink of the eye to make you understand that you might be involved with him in any particular kind of complicity. And it would have been very difficult for people who were primarily involved in art to have any special complicity with him. The history he's involved with isn't necessarily art history at all. The influences he was registering are much more vast than that. If you want to find a history for him, or a place in history for him, the history you have to review isn't so much the history of art, but rather the whole history of thought.

He was cryptic and polyhedric and his interests were very wide, and his way of mixing ships and shoes and sealing wax and cabbages and kings was a way of questioning the point to which we've arrived at this end of the whole history of thought, and he thought it might be improved upon. I'm very much intrigued, for example, by his note on verticality and digestion and the way food ends up in our stomachs because of the force of gravity, which is of course absurd. He probably knew just as well as we do that food gets into the stomach because of the peristaltic motion of the esophagous, but he could still be interested in finding the emotions that go along with the idea that the nourishment that works its way into the blood stream is a debt we owe to gravity. He played with these ideas of men as machines or of human bodies as objects that register the most basic laws of nature since he liked ideas that made everything fundamental. That's like his running his Bride not on love but on 'love gasoline.' He was always getting down to some kind of rock bottom. I never forget his answer to somebody's question about what he did the first

thing in the morning; he said 'I breathe.' And he could hardly have been more basic—or for that matter, more germane. It may be a quip, but it also opens up onto everything that's Yoga in Duchamp, just as *eau et gaz* was his way of talking about *prana*, a whole idea of a science of the body. And even though I'm more than willing to leave the topic to others, I can't help seeing that there are any number of parallels between Duchamp and certain kinds of Oriental wisdom. 'Zen and Duchamp' would be an entirely possible argument, and there are all sorts of things on which it could be based, the idea of repeated gestures that don't make any real sense, or even his relationship with objects and the way he could choose them to be Ready-mades. That sort of availability to objects has something to do with the kind of ego that a friend of mine describes as *fractale*—an ego that has really ceased to be an ego since it's what you finally run aground on when you accept the ego as something entirely incommensurable, in the sense that the term is imported from mathematics where the classical example of *fractale* measurements concerns the impossibility of determining the length of the coast of Brittany or Norway with a meter-stick since it's all in and out. Duchamp's own ideas of the *inframince* are close to that, and the *Standard Stoppages* were surely conceived as instruments for measuring things in the sphere of the *fractale*. It's a question of retreating from those almost numerical or geometric concepts of the ego, the 'I,' that are so much more comfortable to live with and that still have a place, say, in psychology or psychoanalysis even though a philosophic cast of mind can do very well without them. Philosophy doesn't really need that kind of concept of an 'I' and especially when the 'I' you're talking about finds its manifestations in forms that might even reasonably be

discussed in terms of a kind of madness, at least from an external point of view. And I think that's perfectly legitimate with Duchamp. His work looks very much like the productions of a madman, and this has since become true of quite a lot of avant-garde art, including my own. You look at his work, and it's delirious and dissociated, and there's a craziness in it—a craziness you wouldn't at all be happy to think of as Surrealism. The Surrealists were involved with a different kind of madness. That people should have called Duchamp a Surrealist is something you can only understand as one of the tricks of historical circumstance, and there's no real sense in that at all. They shared the same city and were friends and he enjoyed it when they could do things together, Breton opened a gallery or something, or they collaborated on the organization of a show for Maeght, but for Duchamp it was just a way of passing the time with people he liked, and there was nothing ever really Surrealistic about him at all. There may even have been a misunderstanding on the part of Breton himself. He'd have *liked* to be able to count Duchamp as one of the Surrealists, and his own psychic position was such that he couldn't easily have spelled out its differences with respect to Duchamp. Breton still had extremely traditional concepts of the psyche, traditional in the sense that they were Freudian, that popular sort of Freudianism, and I don't at all think you find those same sorts of concepts in Duchamp, even though Breton may not have been able to see it that way.

In Duchamp, in his works, you find yourself dealing with an ego that's more or less provisional. It's an 'I' that's not presented or respected as a structural part of the person, it's an 'I' that the person uses when and if and however

he wants, and it's not at all the 'I' that defines the person; what defines the person is his ability to take his distances from the 'I.' What makes his works seem mad is that you can't see the 'I' that's involved with them or responsible for them. And that's clear from as early as things like *Yvonne and Magdeleine (Torn) in Tatters*, and *Sad Young Man on a Train*. Or, for that matter, the *Nude Descending a Staircase*, which isn't at all a painting about speed, the way it would have been for a Futurist, and it's not about the simultaneity of various points of view, as it would have been for a Cubist: it's a vision of what a person is in a sequence of any number of different moments in time. What we see is a whole series of parallel states of existence, and the 'I' simply isn't there. The 'I' is what gives you the impression of always being the same thing, of continuing to be but a single thing through-out the space of time that it takes to walk down a flight of stairs; and it's when you get rid of this kind of an 'I' that you think of that as a question of living a great many different moments and of yourself as a series of enigmas. But so many things have been said about this painting that there's hardly any point in our trying to say anything more, and especially since it's not really a painting with any special appeal for me. If some undreamed-of act of grace could bring Duchamp back for an hour or so, I'd certainly have no questions to ask about *Nude Descending a Staircase*. I wouldn't even want him to talk to me about the *Glass*. I'd want to know about everything from the Ready-mades to the room, from the Ready-mades to *Etant donnés*. About the idea, say, of an art that no longer has anything to do with a public, about the idea of an art that's a kind of spectacle on the part of a hypothetical 'I,' this 'I' that divides itself into an inside and an outside the way it does in that room in Philadelphia. And about, say, the way that links up to the

whole idea of the 'passage' that was so important for him, this fact of getting from here to there, this idea of things in transition, and, yes, that's a part of the *Nude*, and at some point I found it intriguing, but really my thinking about Duchamp started in other places. It was important too that certain works actually passed through my hands.

One of the things I learned most from was one of the pencil drawings he did when he lived in Munich, one of the drawings concerned with the idea of a Bride. For me, the idea of taking possession of a work of art doesn't have much to do with the idea of owning it, it's more a question of simply having the chance to be alone with it. Here that just happened by chance. Duchamp's dealer in New York must have bought this drawing for somebody from Carese Crosby, who had a castle out beyond Rieti, and it got left with me, for some reason or another, for a couple of weeks before being taken to the States. This drawing, for me, was the beginning of the discovery that Duchamp, at least unconsciously, lived in a feminine kind of space. That was the center of an enormous periphrasis. He was always talking about a *vièrge*, always talking about a *mariée*. The drawings he did *d'après* towards the end of his life may have been light and built on quips that seem to reflect the erotic phantasies of a man who's growing old, but this aura of sexuality and femininity was something that he actually lived in, something more than simply some one dimension of his work. And there's more to it even than looking at *Etant donnés* and remarking on the way all of his myths of water and air and all the rest of it come more or less to a head and finally find their explanation through the physical body of a woman. It's rather that his symbols of understanding were always symbols of sexuality, and I often

think back to the way he remarked that real understanding would be for the mind to envelop its objects in just the same way that the vagina envelops the penis. It's as though his head were that room he did; when you look through those peepholes you're peeping into his mind, or maybe it would be better to say that you're peeping into the interior of his body. Instead of being a M. Teste, Duchamp, in a way, was a kind of M. Corps, and inside this body you see these things that he'd first laid out flat and trapped between two pieces of glass, which is also a kind of latent space—a space of ineffable thinness full of allusions and libidinal impulses that are only just barely hinted at, and at one and the same time both prophetic and extremely material: the 'cemetary of uniforms and liveries' and the matches his boxers never fought, the violence of the nine shots and all the rest of it, linguistics in the 'alphabetic filters,' eroticism and even nature, if you like—or even a concept of the future and of becoming in the Bride and all of the people who are standing around her, the on-lookers in all of their various forms, which he fixed into place with only the slightest signs of reference, all these little coughs, all these little examples of what he called his 'weak energies.' And the images too are weak, incredibly weak, which is what struck me so strongly when I visited Teeny and was looking at this incredibly heavy object made of glass and lead wire and cemented into the wall, this *Cemetary of Uniforms and Liveries* that had gone all green, these beautiful little puppet-like figures only a few inches high. More than anything else, it was like the stained-glass window of a church, a cathedral. You look at these things and don't feel a sense of anything modern at all. If you want to admit the truth of it, these things are antiques, something on the order of relics, things that ought to be of interest to an

archaeologist. They all look so incredibly old. You look at his *Wedge of Chastity* and you think of turn-of-the-century dentures and Freud as he smoked a cigar with a prosthesis in his mouth and a cancer under his tongue. And certainly there's nothing really contemporary in the forms and techniques that you see in these works. Who could care now about the idea of making a painting on glass all stuck together with God knows what kind of glue and lead wire? All that's important and all that's left is a certain kind of gesture.

This is what makes it seem so odd for people like Hamilton and Ulf Linde to have made copies of Duchamp's works. The *Glass* is like a talisman or the bone of a saint, and either you're happy with just knowing about it and looking at the photographs and having all the information you can dig up about it, or, if that's not enough and it makes that much of a difference for you, you get on a jet and go to visit the Mecca. Rather than make a copy of it, all you're really supposed to do is to talk about it. But Duchamp himself was, of course, very much amused by their making copies of the *Glass*, and he liked the idea that people should pay him that kind of homage. He was too aloof and aristocratic for it ever to matter to him that people should make mistakes about his work. That was a part of his wisdom. But I also think it was a part of an enormous sense of impotence in front of the fact that he was still almost entirely unknown and ignored. So he was content with just about any kind of interest that people took in him, especially if it was the interest of people like Hamilton, or Rauschenberg, or Cage or Jasper Johns; he was always interested in the artists, and he was more than content with the attention of a few great acolytes. Popular

success was something he didn't really feel he needed. He didn't even know what that meant. That was a part of the aristocracy of him, a part of his marvelous snobbism, if you can call it that. It was marvelous because it wasn't at all a snobbish kind of snobbism, it wasn't based on money or power or anything like that at all. He'd never bothered about things like that and his needs were all very limited; his snobbism had something marvelously self-contradictory about it. Duchamp's not in any way a clear sort of individual, you can't say, 'Ah, Yes!' the way you might about somebody who had always been dedicated to painting the heros of the proletariat. You have to remember that there are people like that too, people who commit themselves to hard and fast ideological purities and always work in the service of well-defined ideas and very precise ideals. Then, on the other hand, there are these much more curious kinds of personalities like Duchamp, personalities that you never really know what to make of and that never allow themselves to be cir-cumscribed—personalities that never allow you to deal with them as though they were large and solid monuments that dominate a mind-scape and serve as clear moral exam-ples. Duchamp is more on the order of a heresy—an entirely generic heresy that touches on just about every-thing, or that's good for all seasons, something like a per-fume, something like an odor, something like the fear that precedes an earthquake, a lament, perhaps, a kind of ultra-sound lament that's just outside the range of hearing. People who've done work like that are a kind of pollutant, a disturbance, you can't think of them as pyramids. One thing you can say about the *Large Glass* is that it simply isn't a pyramid. It's more on the order of a doubt, an insidious doubt that has been whispered into people's ears or filtered

into their minds, or maybe it's a question that allows no space for an answer, that doesn't even contemplate the possibility of answers, just some sort of hypothesis that somehow implies that things might in some way or another be different, somehow not the same.

All of this fetishism about a great big broken piece of glass should really be considered out of place, even though I have to admit that I'm afflicted with it too. But not all afflictions are the same affliction and I'd certainly never get involved in trying to make this fetishism seem somehow reasonable and legitimate and scientifically motivated, which is all sheer nonsense and insensibility. Critics talk about the Bride and the figure of Melancholia, and then they go on and pull out all of the rest of Dürer and babble about how the figures in the bottom half of the glass are reminiscent of Dürer's concept of space. What could Duchamp possibly have in common with Dürer — Dürer, a very great painter, and unconditionally a painter, and a man with all the right allegiances in all the right courts? What could he possibly have in common with Duchamp, whose only allegiance was always to himself? All of that's a madness, a kind of art historical depravity. How could it ever come into anybody's mind that the *Large Glass* should be compared to a painting done in the Renaissance? Classical painting was something that Duchamp couldn't have cared less about. He talked in his notes for the *Glass* about using a Rembrandt as an ironing board, *un Rembrandt pour repasser*. But the critics and the art historians feel they have the right to go and tell him that there's really no difference between his own major work and things he'd have been happy to use as scraps of cloth on which to iron out his socks. That can only be thought of as insulting and

offensive, and they're not even aware of just how vulgar they've managed to be. In the nineteenth century, a friend of the family would have thought it his duty to go out and challenge some of these people to a duel.

The problem with criticism is that it never comes to a realization of the parallel realities that exist in the world, these elementary parallelisms that Duchamp talked about. Criticism has every legitimate right to present itself as a science that wants to understand everything, but in that case it should also realize its status as a purely personal necessity on the part of the person who's writing it. What's horrible is when critics begin to present their conclusions as causes, or when they don't have sufficient sophistication to see that history explains hypothetical relationships between events without necessarily achieving any exhaustive explanation of events as things in themselves. So, if you want to be involved with imagining great historical syntheses, well, if that's where your mind is you have to do it, and if you're looking for a way in which art as a corpus can have its own possible autonomy, there are ways, I suppose, in which that can be maintained; but you also have to remember that the people you're drawing into the story of the history of art may be entirely unaware of the kinds of contexts and continuities into which you're trying to fit them. And it would certainly be a mistake to imagine that the origins you attribute to them in terms of that context are necessarily the origins they'd assume for themselves. It simply seems to make so much more sense to listen to what Duchamp felt like saying on his own. He expected such a lot from his words, and he was terribly careful about them, careful in the physical treatment of them even, careful about where to store away all of the things he wrote down

on little bits and pieces of paper, even notes that he wrote on coasters from some beerhall in Rouen, and when he pulled things out of this hoard to publish them, he'd make the most precise and careful and time-consuming fac- similes possible. He was anxious even for people to take note of the titles of his works. 'The titles are important,' that's one of the things he said. 'Titles Are Important' would, in fact, be a very good title for all of the corpus of the words that he produced, I mean the *Green Box*, the *White Box*, *Marchand du Sel*, and now the *Notes*, and so on and so forth and maybe even the instructions for dismantling and reassembling *Etant donnés*. When you put all of that together, it makes for really quite a large literary—or maybe it's better to say 'para-literary'—production, a pro- duction at least of words. All of that is important too. And of course there's an enormous presumption there, the pre- sumption that posterity would feel the need to figure it all out for themselves. At one and the same time, he made the work of future exegetes both a great deal simpler and a great deal more complex; he offered them all of this mate- rial that's entirely consistent with the images and icono- graphy of his work, but he offers it in a form that can only be described as 'in bulk.' One wonders too why it consists to so large a degree of sarcasms and riddles and *jeux de mots*, which are sometimes even funny in the sense that they can make you laugh; his laughter is one of the things that people who knew him most remember about him. What's the purpose of all this laughter in the work of Duchamp? Even if there are ways in which I see him as presumptuous, he always remains a person who never made the mistake of taking himself too seriously. He had a taste for combining words and ideas and situations as absurdly as possible, and less from love of paradox than from a sense of the parallel

and simultaneous existence of many different forms of logic. He was involved with putting together contradictions to see what the effects of the juxtapositions would finally turn out to be. Rather than look for his principle contradiction, he would try to see how all of his contradictions could fruitfully live together. It's as though he were always trying to keep his sense of the unevenness of experience in good working order, just the way you stay in practice at the piano, or the way a juggler stays in practice with throwing around rubber balls, but instead of juggling with rubber balls, he was juggling with different orders and levels and kinds of ideas, seeing them as parallelisms, or creating an order of parallelism that could include them, like Roussel, say, with all of his parentheses and disassembled words. And the same thing is happening with all the simultaneities in the *Large Glass,* all the various orders of libidinal impulse that he peeled away into this transparent film, and all the complications and complexities of the Ready-mades, where you also find a constant and almost dizzying lack of retrievable meaning, a constant loss of quality, until finally you end up with something like UNDERWOOD, you couldn't get any lower than a thing like that unless you were to use an old house-shoe. You could say he was finally quite serious about descending that flight of stairs.

And all of this—which is the side of Duchamp that I find most seductive, the part that most intrigues me—all of this seems to lead to a vision of the subversion of political power. And the symbol of that for me, most particularly, is his urinal. I'll spare you my attempts to explain that since I always bog down and turn the ideas of use value and exchange value into terms that any orthodox critic of

political economy would have to find ridiculous; but it's this quality of Duchamp the subversive, the *empêcheur* who has a lesson to teach us, and the lesson is that it's possible to manipulate contradiction and to admit the existence of parallel thoughts and parallel systems and parallel realities, and that's almost the very definition of what people now talk about as post-modernity. Post-modernity is seeing this huge confusion of unrelated and conflicting ideas and then turning the impossible trick of managing to live with it. It's this universe of superabundant information that keeps you simultaneously aware of all the horrors on the face of the earth, all the minorities that are being robbed of viability and systematically destroyed. The real and possible diversification of the world becomes a part of some enormous media spectacle that makes us simultaneously cruel and compassionate, cynical and yet totally available to anything that asks for our availability. This era of enormous complexity is an era that this man Duchamp seems to me to have opened up. He opened it up to give us the courage to undertake some kind of solitary voyage as experimenters in co-existing with contradictions through the creation of all sorts of paralogical effects that can go from political subversion to laughter. The very same mechanism seems to me to be responsible for both. And that's the place where Duchamp meets up with Freud, or with Freud's way of insisting on that air, that perfume, that odor of something beautiful about a quip, something that's unexplainably beautiful; and in all of these curious works by Duchamp there's that same air of beauty, works that go from the kineticism of some of his early experiments to the total theater of the Ready-mades, and finally then to this stage set that he called *Etant donnés* —all of them so many monograms, 'incommunicable phantoms and inimitable

models of possible empirical intuitions without discernible or definable rules.' Duchamp was the first great volunteer in the experimentation of living and dealing with contradiction, like those people who make a profession of putting out fires in oil wells. I mean, there's always somebody who decides to go and do things that are practically unimaginable for everybody else. Maybe the people who put out fires in oil wells do it for the money, but there are always these audacious types of individuals who do things out of ideas of solitude, or originality, or because of some other kind of bizarreness, and they express themselves in ways that don't have the comfort of the approval of anyone but themselves. And that's the sort of person I think of Duchamp as having been.

MARCEL DUCHAMP: Door of *Etant donnés* —*1ᵉ la chute d'eau, 2ᵉ le gaz d'eclairage,*
1946-1966. Philadelphia Museum of Art: Gift of the Cassandra Foundation.

We have all of this incredible mythological world that Duchamp spent his life elaborating, the world that appears in all of his various notes, the world of strange ways of behaviour that you find in all of his apparently meaningless objects, the world of the *Large Glass* and *Etant donnés*, and the question we've been skirting or trying implicitly to ask is very fundamental. We're asking ourselves about the extent to which we have the right to have anything to do with this world of myth at all. I mean, what sort of pertinence does it have to us? This mythology, as we said before, is so incredibly hidden, Duchamp never helped anybody to figure it all out, it's something he kept incredibly private, and to what extent, then, do we have not just the right but even the possibility of taking any real or useful interest in it? We're calling it a myth, but a real myth, after all, is something very communicative and immediate: you understand it even when you don't understand it, you understand it from the ways it works on you, it's not something to be analyzed at all. It's something that touches you emotionally and spiritually and sets up certain harmonics in your psyche, but with Duchamp's myth that doesn't seem to be true, or at least no one talks about the way in which it is true. There are no simple glosses the way you'd expect a simple gloss on a fairy tale, and there's no clarity in the emotions that the myth excites. You wonder how you're supposed to react to this incredible story, and you wonder if that in itself isn't already a sufficient reaction. You wonder if you're to delve any more deeply than that. Creating a use for Duchamp is one thing, and creating a use for the substance of the myth that he set his mind to producing is something else. That's a possibility. Maybe this myth, these myths, are things that he invented entirely for his own use, and pretending that this

myth is part of the public property that he himself becomes as an artist could very well be a mistake. A very big mistake. Duchamp, after all, was very free with statements that make such a conclusion almost inevitable. He seemed to feel that all myths are personal myths. When Cabanne asked him about the kinds of importance that other people's art could have for him, he replied that art in the social sense of the word wasn't of any interest to him. He says he enjoyed talking to artists with new ideas but that he felt no need to go and see what they do. And listen to what he says when asked about his views on the evolution of art: 'I don't have any views at all on that, since, basically, I ask myself what sort of value art can possibly have. Art is a human invention and if there were no human beings, it simply wouldn't exist. It's not as though all human inventions are necessarily things of value. There's no biological origin for art. It's a question of something that has to do with taste.' A little further on from that, he says he thinks of art as belonging to the sphere of masturbation. But the interesting thing is that he never seems to have any desire to make an exception of himself. Other people's work inspires these attitudes in him, and there's never any intimation that his work shouldn't inspire the very same attitudes in others. He says that it's the people who look at art who declare that that's what it is, and he more or less puts himself in the class of his example of the Congolese sculptor who never imagined that one of his masks or wooden spoons would end up in Paris at the Musée de l'Homme. There's a point, too, where he talks about De Gaulle and remarks that he was once a hero, but that heros who live too long are destined to a *degringolade*, a downfall, which is quite a remarkable statement from a person who's being interviewed because he too has an

heroic role to play as a grand old man, already at more than eighty years old. And he knew perfectly well that De Gaulle was three years his junior, since he launched into this little broadside immediately after having been told so by Cabanne. You can't quite tell if he's making fun of Cabanne, or making fun of himself. In any case, it's practically an invitation to look at the ways in which he too may have been a hero who lived too long and finally had a downfall.

That's not at all a blasphemous thought, and why shouldn't that doubt be legitimate? Not everything he said holds up in the same splendid way as the best of him, and not everything he said makes the same kind of sense. He hardly makes sense at all when he's forced to be explicit about things that are really outside of his domain. Hearing him talk about politics is painful; you listen to his comments about film as incapable of being a real means of expression, and that too is something you'd have preferred not to hear him say. No matter how much you care about Duchamp, there's simply no point in refusing to see that there are any number of areas all around him or within him where a certain skepticism simply isn't out of place. It's so boring that everybody is always totally for him or totally against him. The people who are for him turn him into a giant or a god, the people who are against him try to cut him down into nothing or to insult him the way Hess did by talking about his Ready-mades and concluding that he was just another nobody with a great interior decorator's eye. Why don't the people who care for him ever bother to play the devil's advocate from some positive or affectionate point of view? You could simply look at the facts from the simplest point of view and say that he had these ordinary

middle-class beginnings as the son of a notary public in Normandy, that he turned out to be a very good painter, that he made many very beautiful paintings and then got tired of it and lived like a dandy; he had a charm that made him the center of attention for a whole group of people who more or less kept him for all of his life, and it was a pleasant life even in spite of the fact that the world went on its way, there were wars, there were floods, there was Hiroshima, there was Nagasaki, and then late in his life he did a few odd objects and then finally this odd, realistic, or fake realistic room.

And do we really have to say that *Etant donnés* is all of these fabulous and fantastic things that all the official commentators seem to be convinced they have to say it is? So there's a door with a hole in it, and so what? You look at this hole, and then you look through it and there's this statue lying on the ground with its legs spread apart, and then there's the *bec auer*, and this, according to the commentators, is supposed to be the synthesis of everything, the explanation to end all explanations of everything he was ever supposed to be about. There's something a little ridiculous about that, if I'm supposed to say what I really feel. Maybe it's that I haven't actually been there and felt the fascination of the actual thing. I haven't gotten on a plane and gone to Philadelphia to look again at the *Glass* and then through the hole in the wall, or, rather, in the door from Cadaqués, I haven't seen the way the bricks have been put around it, I haven't been close enough to have a feeling of the secret maneuvers and mechanisms that are inside the thing and that determine the way it's animated. But I still rather tend to doubt that this is the greatest work of his life, that it makes everything he did

before propaedeutic, or that it's the final revelation of all of his secrets and all of their final import. How would things have stood if he'd never done it? Would I have been happier about that; would all of us have been happier about that? Couldn't it even be that all of this enthusiasm that people have mustered about this work is a way of masking a profound sense of disappointment with a theatrical *coup* that nobody really likes or knows what to do with? Cage comes admirably close to saying that when he remarks that *Etant donnés* is the *Glass* all over again, but cast into a form that's difficult for us to accept. It was much more beautiful to think about the fourth dimension of a nude rather than to see this sprawling open cunt. How can people get so excited about looking at the cunt of a statue? And then they go on about, 'Oh, yesss, because the arm is missing, the arm you know is *broken off*, and there was already *In Advance of the Broken Arm....*' and really, haven't we heard enough of that sort of thing? Instead of trying to protect him by mustering some false enthusiasm — which is a very dangerous thing to do since there's a baby that may finally be discarded with some of that bathwater — I'd prefer to see a successful debate that defends the position that this work is no more than the sign of the senility of a man who was great in his time, rather than some revelation of how slight a figure he always was. That would be a mentally healthful thing to do. There's nothing wrong with a fall from greatness, since that's in any case reserved to the great. And I'm saying this from the point of view of somebody who has to thank Duchamp for a lot. He helped me to build a whole world of my own, he has functioned in my life as an instrument that helped me to get on with the whole business of living, and that, precisely, is why I feel the need for this kind of clarity.

And maybe I'm wrong, maybe it's fantastic, maybe we're all supposed to go to Philadelphia and look through this hole and come away enlightened; but I feel disappointed, really, there's no way I can get away from it. The more I think of it, the more pictures of it I see, the more I hear it described and glowed about, the less I feel like joining in with the chorus of everyone who's saying now how great it is, how fantastic, how marvelous, how much the *summa*, synthesis, and clarification of everything that Duchamp did before it. Personally, I'd much rather look through a hole and see Cranach's Venus if I'm supposed to be interested in some sort of sublime vision of sexuality; how are you supposed to see that sort of thing in a woman made of pigskin? I know, of course, that I'm exaggerating and playing the devil's advocate, but my point is that that's an entirely legitimate thing to do. Duchamp as I knew him was a marvelous old man, and I have no doubts about that, but that doesn't mean that I want to have him pull my leg and make fun of me, and pulling people's legs was one of the things he was very good at doing.

Why does *Etant donnés* have to be something so terribly much more important, say, than UNDERWOOD, and why can't I imagine an affectionate way of asking him why he decided to do it, and even if it wouldn't have been better if he hadn't? Why can't we look at the whole thing as a send up, something to have a good laugh about, a joke? That's another solution, and what would be wrong with that? That would certainly explain what I see as the quality of it, this sense of its falling short of something; that's typical of humor, typical at least of quips and word play, humor can be an experiment in dealing in a positive way with disappointment. You could think of this work as an

exercise in irony where he pulls all of his life and all of his fundamental interest in eroticism down to something on the order of a shaggy dog story. The proper reaction in front of this room might be a kind of wince, and instead what you get from the commentators is a kind of artificial ecstasy. I come away with the impression that they're simply not telling me the story the way it ought to be told. Why do people have to have such an awful lack of sense of humor when they talk about this room? Why can't they grasp the real *feeling* of it and imagine that Duchamp himself was aware of it. He was working on this piece at much the same time that he told Cabanne that what he liked about happenings was the way they were involved in giving people a sense of boredom. He thought of that as an interesting thing for art to do. Why can't we imagine that this work, *Étant donnés*, was his way of giving people a chance to explore the emotion of disappointment? And that would certainly be coherent. We've already talked about the possibility of seeing a thing like that as a part of the meaning of some of his phonetic puns. Maybe you react to *Étant donnés* much the same way that you react to deciphering L. H. I. E. O. P. I.

My whole relationship with Duchamp is something very personal, and I'm interested in all the things he did and all the things he said, and his work, including this work, is of course a part of all the things he did and all the things he said, but more than a certain amount of fetishism for the work of an artist is a different kind of story and connected to different kinds of values—values that are social and attributed. You can feel too that one of the important things about Duchamp was the way he confuted or at least had a tendency to confute that kind of sense of

value. He could say, for example, that most of the work of an artist is just a question of repetition and that even the greatest artists only do five or six really fundamental things in their lives, things like the *Grande Jatte* or the *Demoiselles d'Avignon*, and then that all the rest is just filling in the empty spaces with something to do day by day or for a show to do every year or so. What I'd like to be able to ask him is whether or not this incredibly complicated stage set in Philadelphia is one of the five or six things that he thinks were really what his work was supposed to produce. One of the five or six masterpieces. That's something I'd really have liked to be able to ask him. It's simply very hard to see this thing as the burial place of modern art, the *non plus ultra* of modern art, the ultimate challenge of modern art the way the *Glass* was. You look at the *Glass* and it's as though you hear a voice that tells you that you can consider yourself up to snuff if your gaze can travel past it and settle onto something else that you can think worth doing. You just don't get that same kind of challenge looking through a hole into a closed-up room that presents a pigskin dummy to the center of your field of view. He's supposed to be the great *empêcheur*, but that pigskin dummy doesn't really amount to a veto of very much. It's like that church in wherever it is by Matisse, the sort of things that old men get around to doing because they've forgotten all the reasons why they shouldn't be done. Instead of converting himself to religion, Duchamp just converted himself to realistic models of female sexual organs. He converted himself to explicitness.

It's the sort of thing that could never have been done by a man who'd been in a hospital delivery room; he's involved with a sexual effigy that's completely and incredi-

bly cold; it's an effigy that's explicit and no longer simply about the psyche's curious definitions of desire, but it still has nothing to do with all the rest of sexuality, with the generative aspects of sexuality, the blood, the amniotic fluid, the pain, and sure, it's not that you think of that everytime you see the sex of a woman, but if I'm going to turn the representation of a woman's sex into a fundamental theme of a part of my work, that's a valence that I have to deal with too. That's part of what I have to think of erotic attractiveness as being all about. Another thing I personally find so upsetting in this work is that it's also the first and only work in which Duchamp deals with nature or with the earth. These are themes that are extremely important for me, and I find it chilling that their only appearance in the work of Duchamp should be in this particular context; there are bundles of real twigs on the floor of this room, which is supposed to be the ground, there are photos of trees, and a waterfall, and a cliff, and if this is a discourse that has something to do with the earth, well, it's simply not a kind of discourse that gives me any satisfaction. It pretends to be about the earth and the female valences that are mythologically connected to the earth, but if I had to define the identification that's required of me as I peep through the hole to see this vision, well, the only thing that really comes to mind is a huge erect penis. It's a peep show, and there's something almost morbid in its idyll. You're invited to find something erotic in a tremendously ambiguous effigy of a woman's body, broken, truncated, its pubic hair shaved away, and represented through the use of stuffed pigskin. The only real problem of interpretation is as to whether or not the subtle horror of the piece is something he was conscious of and consciously trying to make use of. That's a possibility that it

would be stupid to overlook, but whatever the feelings the piece ought to excite, I don't really see that lyrical enthusiasm is a sensible part of them. And no matter how you want to look at the problem, I'll never be able to think of this piece as the thing that sums him up. My attitude to this thing is simply that he once did that too. Among all the monograms or ideals of sensibility put together by this man, so many different and even conflicting monograms — and his greatness lay in having the courage to undertake that kind of task — it's just another of his myriad and insidious disturbances, simply another enigma. I said before that Duchamp is a forest, and that's still how I feel. He's a forest where some of the trees are important, where some of the trees are tall and majestic, others are more like shrubs and bushes, some of it is undergrowth, and moving around in this forest isn't by any means as simple as it might at first appear to be; sometimes it's dense, at other times there are uncertain clearings where you can lose orientation and not know what direction is best to follow; and you don't necessarily have to cross over to the other side of it, that's not what a forest is all about. It's a place to wander about in, in a way you have to find a way of living there, and I've been living there now for a good number of years. Some of the things I've found there have been good food for thought — fruits, say, that give the mind a kind of nourishment that it has a need for, and other things have proved to be will-of-the-wisps. But if this is what I've been doing, I imagine it's what I'll continue to do. And when I stumble in the midst of this forest onto a hole in a tree that gives onto the vision in *Etant donnés*, it's not at all that the forest is worth any less for that; it's simply a little more complicated. Even though I feel it legitimate to express any number of doubts about this piece, that doesn't do

anything to diminish Duchamp in my mind. Quite the contrary. It makes him just that much more likable, all the more human. What do we want with a Superduchamp who can only be approached in a tone of fanfare and celebration?

And then yes, and then no, and maybe I'm right and maybe I'm wrong. And perhaps it's mistaken to object to this room simply on the basis of what it contains. My objections, really, have more to do with something I feel that's missing, and my mind runs off to a passage I remember in D'Annunzio where he talks about a sea shell, about entering a house and feeling that this was like placing a sea shell to his ear and hearing a 'dark and distant rumble' that was as though the sound of the blood in his veins. That's the sound you always want to hear from a work of art, and that's the sound that I simply haven't yet heard from *Etant donnés;* but, then again, I have to admit that that's not quite the same as saying it's not really there. It's clear, too, that Duchamp had a reason for asking that this piece never be seen in photographs, and it's something of a shame that his wishes haven't been respected. Anything as delicate as a work like this, delicate in the sense that it's so full of ambiguities and possible weaknesses, really ought to be given a chance to reveal the way it can work on you as an actual presence. Perhaps it's the photos that make it seem so falsely celebrative, since they reduce it simply to an image, and maybe it ought to be something more or something other than an image. Maybe what I'm finding so dissatisfying is simply the description of a thing that wasn't meant to be described and, perhaps, that simply doesn't bear description. And I know that he was never dishonest. There's no way to imagine that he did this thing

without that dark and distant rumble having been there for him. What D'Annunzio was talking about with this rumble is a noise inside yourself, a noise that runs through your blood, it's not at all the rumble of the house itself. And certainly this rumble is something you feel when faced with all the rest of Duchamp's work: what his work, in fact, requires from a spectator is simply an availability to hearing it; his work doesn't ask for or require much criticism at all. It pulls you into an atmosphere of a special silence, an atmosphere of an almost ferocious lucidity, and you're then to listen down inside of yourself for the rumble of all the ideas that come out from it. Putting your ear to a shell isn't finally very different from turning your eye onto a work by Marcel Duchamp. With a shell, you hear and feel the rumble of your own senses and your own emotions, and with Marcel you feel the rumble not only of your senses and emotions but of your own ideas as well, and perhaps more than anything else of your own games with your own language. It's your eye that has to seek out this hidden noise. Duchamp knew exactly what he was talking about when he implied that painting has to be made half and half, half by the artist and half by the spectator; and making the other half of our arrangement is what we're up to here. That might not even be a bad title for this book: 'How to Make the Other Half of a Marcel Duchamp.' It's clear too that the other half that everybody makes for his own Marcel Duchamp has to stand up on its own. You can't just get involved in whatever idiocy happens to be passing through your head; you have to make your half as well as he made his.

Part of what disturbs me about *Etant donnés* is that in making it Duchamp was making something that I'd always

suspected that he must have had some need to make. But his finally making it disturbs me just as much as I was disturbed before by the fact of his not having made it. He made a statement about his relationship with particular interior spaces, the interior space almost of a house, and that's something that has always been extremely important for me. I don't want to say that my own experience is a touchstone for judging the validity of the experiences of others, or a filter through which other people's experience always has to be seen, but if I'm making my other half of Marcel Duchamp, these things are at least a part of the basis I have to move out from. For me, it has always been important to try to discover a concept and a form, or a correlative, of the interior space in which I feel my life takes place. I think of it as a room, or a house, or a container, and I've always defined it as a feminine kind of space. It's feminine because it's a space of uncertainty, a space, too, of which my knowledge can only be uncertain, a space of anguish, a space where things don't allow themselves to be measured. That's what the whole area of femininity is about for me; it's an area that's cosmic and lunar at one and the same time. And what became clear to me in studying that drawing called *The Bride Stripped Bare by the Bachelors* is that some such space had an importance for Duchamp as well. But it was always something that he ever so barely hinted at until he finally made it explicit with *Etant donnés*. It's as though that were the argument he'd decided to leave to last. None of his earlier work is really a representation of this sort of total and feminine space since he limited himself to talking about things that are tangential to it; he always talked about eroticism, about eros, about the communication between different kinds of sexualities, which is perhaps an inelegant way of putting

it, but I'm thinking about the way the separations between the sexes are so absolutely total in the *Glass*. The Bride is one thing and she has her own specific and particular place, and the Bachelors are something else and they belong to some other place; she's up there at the top and they're down there at the bottom, that's quite clear. And the Bride's domain and the Bachelors' domain are as though on an equal footing. There's no feeling that the space of the Bride is an any more fundamental kind of matrix. It's only with *Etant donnés* that Duchamp got around to thinking about and constructing an entirely feminine space, but this was after having given others, or at least after having given me, the possibility of getting there in an entirely different way. And this, I suppose, is the fundamental reason, or at least a plausible reason for my refusal—and it's almost an *a priori* refusal—to pay a great deal of homage to this piece.

I had a period of an extremely powerful identification with Marcel's idea of *eau et gaz*, which is so much of what we were talking about before in *How to Imagine*, and I've never seen anyone else describe so strong a sense of identification with some specific thing that comes out of Marcel's work. I'd assumed this idea of *eau et gaz* as the very definition of the entirety of my personality, the very definition of my ego. But Marcel's own version of being *eau et gaz* saw these elements as something free and dynamic and energetic, and for me that form of total availability couldn't work. As *eau et gaz*, I needed a container, a reservoir, some ideal female space in which to keep myself, and that finally became the earth itself. 'Etant donné Gianfranco Baruchello' as a form of *eau et gaz*, I had to discover the possibility of transplanting myself into the earth, and

that's what the whole adventure of the farm Agricola Cornelia was all about. That was the feminine space that had to contain me, and so when Marcel finally offers me this symbol of a room and the body of a woman, I feel that I've already gone beyond that. I've found a different series of deductions that starts out from the same set of givens, a different solution to the same kind of problem, and since I've got it, I see no reason not to keep it. This symbolic body of a woman in a landscape is no longer of any use to me, I've already left that behind me and entered into the earth itself. And with Duchamp there's never any earth at all, he says the *Glass* is an 'agricultural machine' but you don't see a lot of dirt there, what you see is his constant symbolic return to the vagina. You could even say that I've done something that's in competition with his idea of a feminine space, and my attitude to what he's done can't possibly find a way of being anything but ambiguous. At one and the same time, I understand it and don't want to have anything to do with it. At one moment I can find it ridiculous, and at the next I can be talking about the way I know it had to rumble, at least for Marcel. I find myself rejecting this work much as I found myself rejecting the *Box in a Valise*, it's the same kind of conflictive relationship all over again; I wanted that *Box* and I'm sure I could have found the money to pay for it if I'd wanted to, but there was something that stopped me. And I've got the same problem again today; what would it cost me, after all, to love this object, this room? What's the price I'd have to pay to find a fascination in it, and what is there about it that keeps me from wanting to pay it? But there's an answer to that question, and I don't at all imagine that a trip to Philadelphia is going to make me change the way I feel.

For me, this piece is Marcel's first and last statement about a problem that concerns me directly, a problem, say, that he finally discovered to concern him too, but it concerned him in some much more minor way, and my solutions have already been stated, and I'll stick to them. They're solutions to a problem that he helped me to state, and they're solutions that have their roots in everything he did before, but I went off into a direction that never interested him, and that's okay; he never had any need of nature, never had any interest in nature, his 'agricultural machine' functioned at levels that were abstract. I've gone off and tried to make it function in the places that seem to me most properly specific to it, but that's my business, and that's okay too. For me an agricultural machine has to go back to the derivation of the word and *colere ager*, cultivate a field, and it's supposed to be grinding up something other than just sperm. Or water or gas or vaginal fluids. For me, it has to grind the soil itself, the rain, and seed is to be thrown into the earth, the *Eclaboussures* have to find their destination in the ground. I keep on thinking about a phrase from the Talmud that talks about curing certain wounds by rubbing them with earth from the shady side of a latrine, and the way you go about that can't be purely symbolic. So why not bring Duchamp's ideas about the Bride and the figure in *Etant donnés* right back down to the earth, why not see them in terms of the factors of the earth that they somehow or another refer to? The waterfall turns into rain, and you pray for it and you're grateful when it comes because if it doesn't the earth will never grow fecund and blossom; and the splashes, rather than hanging in mid air, become the beginning of a germination. Okay, it's clear we can't do a book called 'Marcel Duchamp in an Agricultural Key,' but, then again, why not? Maybe the

references in his work would even support that. And maybe not. Maybe this is just the noise, the dark and distant rumble, that I myself have put, and have to put, into my own personal sea shell. What I end up with isn't at all the impression that I've somehow gone beyond Duchamp—since art, after all, is always a repetition of the same thing, or a re-examination of all the same themes— but I see that my ways and modes of working are different from his even though he's my starting point, even though my work starts out from things he somehow gave me license to do.

If we go back to that idea from Kant, the idea of the monogram as a painter's ideal of sensibility, why can't that be extended into thinking that every monogram is just as good as every other monogram, that every ideal of sensibility has a covert relationship or a symbiosis with every other ideal of sensibility? What would it be like if we were to say that all of Duchamp's production of ideals of sensibility was connected to all of the other possible ideals of sensibility that coexist with them? Why can't that make for a credible whole, a credible set of individual parts that tolerate and even justify each other, with no causal relationships between them? If this is a manual on the use of Marcel Duchamp, telling people always to hold such an hypothesis in mind is one of the most important instructions of all. And isn't it odd then that we find a similar terminology in the *I Ching?* Similar because here we're talking about monograms, and the *I Ching* is all about hexagrams, and what would a hexagram be except a group of six monograms? So one monogram is an ideal of sensibility, and you put six ideals of sensibility together and that makes for an oracle. Kant probably wouldn't approve of

that, but there's a sense in it anyway, or at least a possibility of sense.

The problem isn't to be another Duchamp, but to be just as monogrammatic. The problem is to know how to be his peer. And that idea of peerdom doesn't have anything to do with measuring yourself against his genius and declaring that you're a genius too; it's not any sort of Romantic ideal of acceding to the spheres of the elect who declare *J'ai marché droit et calme dans la vie*. There are any number of ways of marching *droit et calme dans la vie*, and Duchamp knew at least a few of them. But the very nature of his intelligence had something to do with allowing just about anybody at all to walk alongside of him. His message isn't an aristocratic message that's only for finely turned-out intellectuals, and that's what was really scandalous about him. That's the scandal of deciding that you too can be Duchamp, the scandal is that you can do it when you realize that anybody can do it. All you have to do is to do it well, which is to do it with honesty and a sense of the quality of the moral example you're deciding to live with.

Duchamp and the Large Glass, circa 1964. Photo: Baruchello.

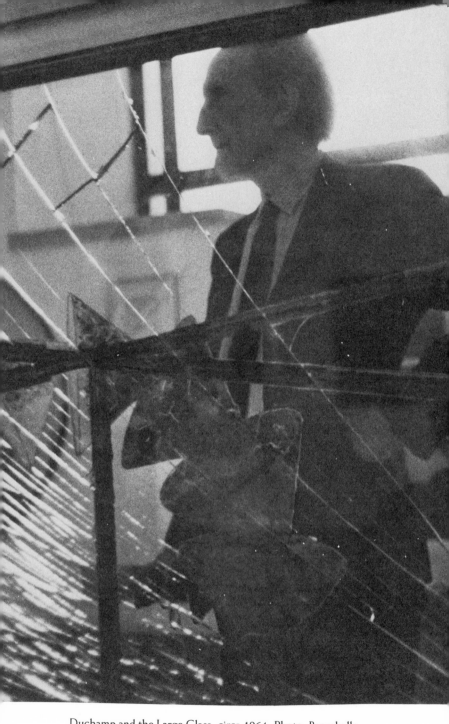

Duchamp and the Large Glass, circa 1964. Photo: Baruchello.

We've decided that we're going to write this book, and now we're sitting here and we're writing it. You have your reasons for wanting to do it and I have my reasons for wanting to do it, and it's inevitable that they can't be the same reasons. It's as though you've elected me an expert on a subject where I might not have elected myself as such. We're sitting here in front of a tape recorder, and we're letting things come out more or less as they want to come, and we have no way of predicting what form this is all finally going to take. We're wandering through whatever knowledge and sensibility we've developed over the years with respect to this person that the both of us find interesting and intriguing and at times even disturbing, and there are moments, I think it has to be admitted, when we're not quite certain that this is something we really have the right to do. This isn't happening in a vacuum, we're not simply opening our mouths and waiting for the flow of some miraculous oracular voice. We're trying to be careful, we're not interested in saying things that are stupid or beside the point, the tape recorder isn't always running, sometimes we turn it off and check on a date, a place, a circumstance, a name, or a title. There's this tape recorder sitting on the floor between us, but we're also surrounded by mounds and mounds of books. We've got Schwarz's book and Lebel's book, we've got the statements collected in the Mashek book, we've got the catalogue for 'Not Seen and/or Less Seen' when the Mary Sisler Collection was shown at Cordier and Ekstrom, we've got the catalogue for the exhibition at the Pasadena Museum, we've got the four-volume catalogue of the retrospective at the Centre Beaubourg in Paris, and we've read the essay on perspective it contains by Jean Clair, we've got Octavio Paz's book *L'apparence mise a nu*, we've got Lyotard's book on *Etant*

donnés, we've got Calvesi's book, we've even got the book that Bonito Oliva published in Naples, we've got Hamilton's typographical version of the *Green Box* as well, we've got the Sweeney interview, we've got the interview by Cabanne, we've got the issue of *View* that Charles Henri Ford dedicated to Duchamp, we've got the *Notes* that were put together by Paul Matisse and published in Paris; there's also *Victor*, the novel that Roché wrote about Duchamp, we've got the catalogue of the Arensberg Collection in Philadelphia, we've got the catalogue that the Philadelphia Museum published in collaboration with the Museum of Modern Art in New York—we've got all of this stuff and a lot more of it as well, and we're dealing with some of it and deciding not to deal with some of the rest of it. It's not as though Duchamp were someone we can want to reveal to the world since the world already talks quite a lot about him as it is. And so what makes us think that we have anything that we can add to that? Or maybe it makes more sense to ask what part of this enormous literature is something to which we'd like to make some minor contribution.

The point, simply, is that not all of this material is comforting. Some of it makes you feel that everything to be said has in fact already been said, some of it too can give you the feeling that anything you have to say is going to be hopelessly silly and tremendously beside the point. Duchamp has been analyzed so thoroughly from so many points of view, his complexity and his difficulty and all of his art historical importance have all been so insistently insisted upon, you're preparing this little report on something you've done with the forty dollar chemistry set you've been given for Christmas and keep in a corner of

the basement back behind the washing machine and then suddenly the dream has gone all wrong and you're expected to deliver it to a congress where everybody is at least a chemical engineer or a nuclear physicist and the moderator has won three different Nobel prizes. I have my memories and reflections and I don't think of them as being useless, but Duchamp has been a subtle and personal influence in my life and not an object of decades and decades of study. He's only a presence I remember, a teacher, perhaps, from whom I've been able to learn a few things that have often been useful for me. I know, of course, that I'm understating it and seeming to toy with false modesty, but it's difficult to make a claim even to so little when I look out around me at all of these tomes of Duchampics, Duchampistry, and Duchampology. It's not at all easy to come to terms with all of these people who've studied as much as possible of everything about him, and you begin to feel that maybe just talking the way we're talking here is something really rather third rate to do. They make you feel like you ought to go back to school and learn what it means really to try to understand something. All of this incredibly complicated exegesis of Duchamp occupies a kind of space, and they're saying that Duchamp is something very very serious and you're simply not supposed to talk about him unless you're one of them — one of the Ph. D. s in Duchampian Engineering. All of these volumes of scholarly exactitude make for a very real disturbance, and so much so that it's difficult at times even to hold on to the by no means indifferent consolation that it's Duchamp himself who comes to our rescue. I have to make an effort to remember to turn back to the things that he himself had to say. But that's all right, since, when we do, they're tremendously comforting, and the idea of

what we're doing here continues to make sense; I suppose that's still another example of how he continues to be a source of encouragement. The dissertations rattle back and forth and address themselves to each other and dispute with each other and enhance each other and correct each other, and then we return to some interview he did and I rediscover the exquisiteness of someone who could say, *'Il y a eu tellement des cafés dans notre vie'* or *'Lire les lettres c'est très amusant.'* When you read through these more biographical sorts of things, you discover a thousand little odds and ends: his attitudes, his wit, the people he lived with, the places he went, how much so and so paid for this or that, little things that are always amusing or that have the give and take of lively conversation, and all of these things encourage you to think thoughts and make comments on your own; they help you see the propriety of making comments that are simple and human, and working up an essentially human approach to Duchamp is what I decided I wanted to do when we began to talk about the possibility that this book might be worth our time to attempt to write. So Duchamp himself doesn't bother me at all. Where you begin to feel your stomach go all queasy is when you open the scholarly or art historical books that have been written about him. And you can't simply throw all of this scholar-ship away, as though you were able to pretend that it didn't in some way or another have a great deal of Duchamp's complicity. Much of this stuff has been written since his death, but in the course of his lifetime he was quite happy about the kind of scholarly interest that people were beginning to show in him. And you have to admit that there are ways in which some of it pays off. Schwarz's book is a mine of information, for example, and the general chronology in the Beaubourg catalogue is

something else that's absolutely essential. It's clear and precise and it's very well done, and reading through it gives me a very good kind of energy. I didn't know Duchamp until he was very old, and when I read backwards through this chronology the way I've been doing in these last few days, I find that it tells me something about who it was I was meeting; it tells me something about the kind of story of which my acquaintance with Duchamp was a kind of continuation. So, what makes you feel queasy isn't necessarily the idea that everything that's been written is an idiocy. You feel queasy because so much of this writing represents a way of thinking that you're simply not used to and that's alien to the way your own mind functions. It represents a whole different level of information and erudition and simply of acquaintance with the dictionary definitions of things. The way a mathematician, for example, would define the expression *étant donné*; the details of all the choreography of the personages in the *Glass* as they appear not in the *Glass* but in the *Green Box*; the possible revelations of meaning to be found in the instructions Duchamp left for the mounting of *Etant donnés*. In dealing with these works, people have often been writing about details that simply have never been accessible to me.

So the only contribution I can try to make to the history, or the story, or the myth of Marcel Duchamp is on the order of a foot-note: a foot-note that gives whatever slight enrichment can come from the expression of the opinion of someone who understood certain things from a painter's point of view, and who's not interested in a lot of other things that don't seem particularly pertinent to his position or experience, or needs as a painter—to the needs

he has to satisfy to get on with the job he feels he has to do. The hinges of the *voyeur* inside the room in Philadelphia are things, say, that simply don't interest me a very great deal. If I feel now that I want to make a trip to Philadelphia to have a good look at this room, that's just the same as saying that I'd have liked to see the sculpture that he did with strips of rubber from a bathing cap when he went to Argentina to sit out the First World War—the piece he called a *Sculpture for Travelling*. But of course the rubber vulcanized or something and the thing fell apart, and so seeing it is impossible. I have to see instead that the various consolations that he offers me also include the idea that a painting is something that grows old and dies in much the same way that people do, so there are any number of ways in which our experience of art is necessarily limited. The life span of a work of art, according to Duchamp, is even shorter than a human life span; he says that a painting lives for about fifty years, and that may be very true. A Manet at the time it was painted must have been something entirely different from this dark, brown thing you see today, but I'm also sure he meant much more than that, and that's another place where you find a kind of self-contradiction in him. Duchamp in what he says is, yes, always very comforting, but there's still no getting away from the fact that he can often be confusing. I mean, he builds a room at the end of his life and makes sure it's properly sold and deeded to the right museum before he dies, and then he makes this incredibly complex series of notes on how to take it apart and move it and put it back together again and reinstall it, and the fanfare of all of that doesn't have the air of being a part of a design to keep this thing visible for the next fifty years; it seems much more like something you do with an object that people are supposed to keep on looking

at for eternity. And even his denial of meaning in his work isn't always clear. When he talks with Cabanne about *In Advance of the Broken Arm*, he remarks that the title wasn't supposed to have any meaning at all, and then there's just a touch of something sybilline when he adds that every-thing, of course, finally comes to mean something. There's another place where Cabanne asks him about the inscrip-tion on *Why Not Sneeze?*, and he replies that he simply put it there '*pour compliquer les choses.*' He'd seem, in fact, to have had that intention fairly frequently, and you certainly can't imagine that he didn't bring it off. And so where, really, is the real Marcel Duchamp, one has reason to ask oneself that question. Where is the Invisible Duchamp? Where is the Visible Duchamp? Is it the one you find in his interviews, is it the one you find in the explanations that he always gave of his works, the one who liked to reply with a quip or to say 'Oh, I just did that for the fun of it,' 'I did that to amuse myself,' 'That was just some kind of game,' and just how clear can you be about the possibility of discarding the notion that the real Duchamp is the one you find in the books of the scholars? He's so completely hidden, or he can seem to be so completely hidden, that you have to accept it as natural for people to want to ferret him out.

But then you have to think as well that this is a prob-lem that's not limited to the moments in which you're trying to decide on how it's best to approach Duchamp. It's concerned with all of art, and who is it really who has told us that you have to know everything that it's possible to know about a painter, and entertain every possible hypothesis about his work, if you want to look at his paintings and come away with something it makes sense to

come away with? That seems like a principle that the Duchampologists have not so much invented on their own as taken, rather, from a whole tradition of entirely philological scholarship. And is one really not supposed to notice that all of these very refined minds so seldom hazard an hypothesis or an attitude that truly affects your fundamental aspirations? There are thousands of people a day who go through the museums of the Vatican here in Rome, and aside from people who need an excuse to keep themselves from realizing that they bought that airplane ticket from Des Moines for really no explainable reason at all, apart, say, from that level of absolutely mindless tourism, aside from that, are we really supposed to believe that a person with intelligence and sensitivity and a need to understand something about the quality of what it means to be alive, are we really supposed to believe that a person like that can't look at the work of Raphael and come away with something important, and maybe even have something important and intelligent and intelligible and maybe even moving to say? That would be very depressing. And certainly, whatever he had to say would be about something more than brush-strokes, and aren't the instructions for the disassembly and reconstruction of *Etant donnés* something on the order of brushstrokes? That's a text, after all, that Duchamp left no indication of wanting to publish, which means that it's not at all in the category of the *Green Box*, he thought of it as something to be seen by the carpenters and electricians, and he was probably quite aware of leaving the piece without any sort of new literary accompaniment. It's something to be seen on its own, and in terms of whatever sort of mental baggage you chance to bring along with you. People who come to the Philadelphia Museum often come in bus loads; school teachers come

with classes of students, they walk through the Arensberg Collection and look at the *Glass* and the various Ready-mades and then these perfectly ordinary people end up at the door of *Etant donnés* and they peep through the peepholes, and that must mean something, otherwise why should it be there, why shouldn't it be in a vault where there's a secretary who makes appointments over the phone only to properly presented and properly recommended scholars and their very best research assistants? Doesn't it have to have something that makes it accessible to just about anybody, or at least, say, to anybody who can look at himself and see the aspects of himself that relate to something basic in the sensibility of the last half of the twentieth century? Doesn't the work almost necessarily have something to do with that, and doesn't it make an appeal to people who are aware of a way in which they too have something to do with that? And Apollinaire, what are we to do about Apollinaire and the way he suggested that Duchamp is the twentieth-century artist most likely to bring about a reconciliation of art and the common people? Having sunk to the level of once again reconciling art to the world of art historical scholarship would be sinking really rather far from that. Art is one of the things we find around us, and like most everything we find around us, it's something that we make particular kinds of use of, and it's not by any means clear that the use made of art by art historical scholarship is something that children should be encouraged to train their minds on, children, and young people, and artists, and anybody else. That's something else that Duchamp brought up when he talked about his idea that a painting has to die after forty or fifty years. He said that when he went to a museum he didn't feel any stupor or amazement in front of a painting, and he

was talking there about the paintings of the art historical past. I remember, too, the experience of having been together with him in Florence, where I took him to the Uffizi. He'd never been there before, and we stood in the atrium to look at the Cimabue Madonna, and he didn't say anything at all, really, he just looked at it with the air of being on an equal footing. He and Cimabue were equals and had nothing to fear from each other: that's how I'd describe the quality of the gaze that he had for it. We went on to look at Giotto too, he didn't say the same things to me that he later said to Cabanne, but something like that must have been running through his mind, or was at least a part of his attitude. I can see his attitude all over again, when I listen to the way he puts it into words: 'Art history is something very different from aesthetics. As far as I can see, art history is what remains of an epoch in a museum, but it's not necessarily the best of the epoch, and it's probably, in fact, a kind of expression of the mediocrity of an epoch, since the beautiful things have all disappeared because the public never wanted to preserve them.' And I imagine that the beautiful things that disappear might be, say, the photograph of a very beautiful woman, or a fine plate of fresh oysters, all the pleasures that one had in a life, or America the way it was when he first went there, a kind of world that was still extremely generous and not entirely self-serving or materialistic, all those fine old things that he loved in America, all the fine and beautiful things that he loved about life. The friends, the conversations, the evenings spent drinking with the Arensbergs, or in France, say, with Picabia in the twenties. These were the things that really ought to have been put in a museum, the pleasures, all the *jouissance*. I can even think of his work as a kind of secret monument to *jouissance*. But *jouissance* itself is

something that a museum will never be able to preserve, and all the extremely complicated machinery of his work is only a means of giving us a reminder of what he really felt his life was all about—this *jouissance* that you don't even find in the woman painted by Cranach, or maybe you do. It's a part, at least, of the atmosphere that's typical of a kind of extremely secular painting, maybe you feel it in the bee that goes with the young Eros in Cranach's painting, or maybe you find it as well in a particularly sensuous kind of religious painting, in Giorgione, or in the *Dejêuner sur l'Herbe*, or in the classicism of Canova's portrait of Paolina Borghese, and what about the *Maja Desnuda?* There are thousands of these Brides, and all of them talk to us the way Marcel's various Brides will be talking to us, and for something more than forty years or so. And he knew that perfectly well, but he still couldn't hold back from the quip; it was one of his articles of faith, a necessary and metaphorical belief. It's like that photo of him with a star cut into the hair on the back of his head, since it's not so much a star as a meteor; it's a symbol of things that appear once and are gone, just like the painting that he says can only live for about fifty years. But it was his own rather curious destiny to live to see his life become a kind of negation of his ideas, he didn't finish like a comet at all. He made his first clamorous entry into the international art world at the Armory Show in 1913, and he was at the center of the scene for the rest of his life, and he was around to see his paintings go into museums and prestigious collections when they had already passed the mark of being fifty years old. So, if they died, all these things that people say about them would be a kind of autopsy, and maybe the things they say are all true. But the metaphor in his own belief is that a painting in any case isn't really

supposed to be the object of a fetish, or even something to be owned, and that the important thing is to create a kind of mythology inside yourself. The important thing with art is to learn a certain lesson. And in my own particular case, this lesson came from him to me through a whole series of phases that were first of all learning a few things about him, and then approaching him and getting to know him, and then getting to know his work even better, and then, say, the time that we went together to Philadelphia to look at his things in the Arensberg collection, all these objects that he mystified and demystified, things that he'd made and had left in people's garages, had then seen broken and had then gone back to repair like a handy-man. I made photos of him standing next to the *Glass* and it was rather the way you'd make photos of somebody else, anybody else at all, standing in the middle of a public park on some banal family occasion. And after that there was the period when he entered my work, years and years when he was a constant part of my work and all of the things my work was a way of thinking about. There was a real exchange between us; I mean the show that he'd come to see or the object that I'd send to him, it's not as though he ever said anything about it in the sense that this is good or that's a little better, what was important was his communication of a kind of personal approbation. But now it's a dozen or so years since he died, thirteen or fourteen years, and it's not as though he were the only thing on which my work has been a reflection in all this time. I've been involved with a thousand different problems and a thousand different themes, and most of them have nothing to do with him at all. It has never even crossed my mind that I should elect myself some sort of priest in the temple of the celebration of Duchamp. I've never made a copy of

the *Glass*, like Hamilton or Ulf Linde, and even though I've redrawn it any number of times, I certainly couldn't do it without checking it out in some book, I mean where is it quite that the bayonet goes, and what's the perspective on the chariot, these are things I couldn't really say without looking it up. I'd never even noticed until a couple of days ago that the area of the nine shots had been completely redone since it had gone completely into fragments when the *Glass* got broken, and I still wouldn't know that if we hadn't begun to do this book and to check up a little more carefully on the details of things. That, in fact, is a part of what makes doing this book so exciting for me, and I continue to discover that doing it is something I like rather a lot. It's useful to have all this fresh input about Marcel, all the stimuli and various bits of information that come from browsing through all of these memories and thoughts and reflections and realizing that the things I'm saying are going into somebody else's ear, which makes me somehow more responsible for them, or makes them somehow more completely my own. What we're doing here has picked up a kind of force for me, a momentum that keeps it always on my mind and not at all confined to the couple of hours a day that we actually sit here and talk. It's running through my head in the morning when I first wake up, and I find it there in the evening when I'm about to go to bed, and would it really then be so strange if this sort of reflection on the basis of this sort of experience should turn out to be useful to somebody else as well? To somebody else with some kind of need for a similar kind of acquaintance with Duchamp, a similar sense of relationship, somebody whose interest is a little less dry and a little more vital than having to do a paper at an art history seminar.

And sure, it's clear that there have to be instruments that make Duchamp's work available to people; there have to be solidly researched *catalogues raisonnés*, it's clear that any young artist has to have something that mentions all the pertinent events and gives all the necessary data, he or she has to know what's authentic and what isn't authentic, what stories are real and what stories are apocryphal, how the things were made and what they consist of, that and all the rest of it. But aside from books with good photographs, isn't it possible just as well that they can have need of something that can simply give them the courage to reach out and take hold of Duchamp just as though Duchamp himself were that snow shovel he called *In Advance of the Broken Arm*, just as though Duchamp were an object of use? And he is an object of use, just like his objects are objects of use. And if he said that his paintings would die after fifty years or so, well, that's something it's worth the trouble to think about, and maybe it's true, and maybe there'd be something to learn from that. Why be afraid of that? Why wrap yourself up in some vision of the way he was some Titan? And, okay, maybe he was, but people turn into Titans because that's what other people want them to be. Maybe he's an unapproachable Titan because of other people's styles and modes of behavior and not because of his own. And yes, he's a fundamental personality in all the art history of the twentieth century, but what precisely does that mean? There are any number of things that it could mean. So, on the one hand, let's say it's a fine and proper thing for all of these scholars to be doing their thing, and let's hope they'll keep it up; and on the other hand it's time as well for other people to get on with doing some other kind of equally authentic thing. And if

the experts in exegesis want to look down on that, well, that's their business and I'm not going to worry about it, at least not much.

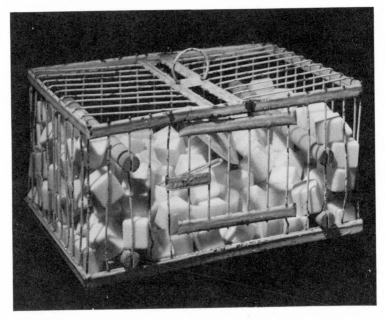

MARCEL DUCHAMP: *Why Not Sneeze Rose Selavy?*, 1921. Painted metal birdcage, marble cubes, thermometer and cuttlebone; 4½ × 8⅝ × 6⅜″. Philadelphia Museum of Art: Louise and Walter Arensberg Collection.

There was a time when there seemed to me to be something almost schizophrenic about Duchamp, which isn't at all a term from the right frame of reference, and I wouldn't say quite the same thing today, but there's still a doubleness about him that's a very important part of the way I remember him. There's no single set of instruments of measurement that can be used to take him in, and that's not only a question of asking myself how to deal with a work made of pieces of a rubber bathing cap, with an ampoule of air, with a painting like *Tu'm*, with the *Glass*, with a naked woman made of pigskin, which is already a very odd mixture. When I think about the man himself, the things I have to put together to understand him are even more disparate than his works. On the one hand, he was a very great painter and very much interested in himself as a very great painter, and on the other hand it was entirely impossible to remain unaware of his almost constant attitude, his pose of enormous indifference. And there were other holes or lapses in that too. I never forget his reaction to that first film I did, *La verifica incerta*. He came to the screening in Paris, and when it was over he said, 'Oh, yes, that's really very good, Man Ray and I once had the idea of doing something exactly like that. . . .' and then he said something about how that hadn't been possible because of the quality of the color film of his day, which was just any excuse at all, and, well, that was the human side of Duchamp. I've always had the feeling that that was the way he really was, still very youthful and full of the possibility of accepting the things that people around him were doing, capable not really of being envious of something someone else had done, but of coming up with that 'me too' kind of statement. That was the side of him that really seemed to me to represent the artist, whereas the

other side of him was something that seemed somehow to have been programmed, programmed or calculated. His attitude of indifference came across as something a little dated and it was as though it had something to do with his way of dealing with the period that had formed him. It was the attitude, say, of someone who had known what quip to use to get the drop on Marinetti, or of someone who was capable of publishing those ironically scathing criticisms that he wrote about Picasso, or of someone who had to be up to snuff in a working relationship with Kandinsky. He and Kandinsky were both of them a part of the Société Anonyme. If you look at the art world as it is today, you see all sorts of mechanisms of attack and defense and prideful disdain, and it probably wasn't very much different back then, except that it must have been a great deal worse with people on a level like that, and incredibly more complex.

He had this 'Project Duchamp' in his head, this idea that 'I am Marcel Duchamp.' And the corollaries to that idea were that everything connected to the market was an absurdity, that the whole concept of painting was finished and dead and done with, that you couldn't do this and that you couldn't do that, and, in general, who could care less, and let's just think instead about the way we breathe. And all of this indifference and terrorism with respect to traditional art was directed to the people of his epoch who could pretend to a stature that was similar to his own. He was addressing himself to the people he could consider worthy of being called into question, and he was very much a part of a debate in which all of them were participating. And of course it couldn't matter that his contemporaries didn't pay a great deal of attention to him and

left him when he was younger with nothing really more than fame. More than that simply wasn't in the cards, and he didn't find a generation of people who truly felt the weight of his influence until the late 1950s. The first people really to be seriously influenced by Duchamp are people who were born just about the time that he first gave up painting in the 1920s. I myself was born in 1924. We were just getting into or out of our mothers' wombs when he began to put the finishing touches on the statement that was to revolutionize our lives as adults. His contemporaries more or less had to ignore him since they all had their own work to do. People, say, like Ernst and Kandinsky had their own pole of the dialogue that they had to create, and it's as though they'd all decided that the only thing to do with each other was to put up with one another while waiting for a verdict on the relative importance of their various positions, to come back from some jury fifty or so years in the future. I remember the time I met Max Ernst in Duchamp's studio in Paris. He came in and took a look at the *Bicycle Wheel* and said, 'Marcel, don't you really think we've had enough of that by now?' He said it very politely, but it was as though he'd expected that Duchamp would have grown up and corrected his childish ways. And what else could you expect from a great technical master like Ernst in front of a bicycle wheel on a stool? It's certainly something that he himself would never have done, and that may be his limit, but then again, that's not the point. That's what was undecided between them, and they both knew exactly where they stood. Duchamp was over eighty and Ernst was close to it and they were still quipping at each other like that; they were talking about this thing as though they were still in their twenties, and maybe they were expressing the self-same attitudes they'd

had at the beginning, the very first time they ever talked about it. Duchamp's myths and pronouncements were something he created as a way of competing with the myths and pronouncements that people like Ernst and Klee were creating at much the same time, the myths of the Kandinskys and Picassos and the Ballas and Boccionis, and even the Man Rays. These were the people to whom he considered himself parallel, the people with messages that he could feel like contradicting and refuting. And these, of course, were the people he'd been most anxious to include in the Société Anonyme: the people who had some claim to real greatness in the avant-gardes were the context in which he saw himself. He had absolutely no doubts about who precisely was the *crème de la crème* and he knew that he was a part of it and he was interested in differentiating himself from the rest of it. And making that differentiation was a question of the whole way he presented himself, a question of all the things he wanted to make people believe about him. That's what was on his mind when he talked with Cabanne about himself and Picabia as having managed to walk through the labyrinth of Cubism and come out untouched. He and Picabia thought of themselves as the real avant-garde, the avant-garde that didn't form groups, the real impresarios of unfettered imagination and the freedom of the spirit. I keep on thinking that that entire book with Cabanne ought in fact to be entitled 'The Duchamp Manifesto.' It's Duchamp's attempt to tell the story of his life in the way he wanted it to be seen and to turn that into the only manifesto he thought it worth his while to sign. It's Duchamp's own answer to the question, 'Who is Marcel Duchamp?' But one of the interesting things for me is that there are places where the book doesn't quite manage to live up to

itself, places where you see the other Duchamp behind the scenes, another and somehow more human Marcel Duchamp; and I have the feeling that that was the Duchamp I personally had the chance to meet, the Duchamp I continue to feel the need to explore. It's as though I still owe him some additional tribute of emotion.

All of this is of course a little oversimplified, and I don't want to push too hard on this idea of his doubleness. I don't want to confine him to my perception of him, and who knows, really, how many aspects there were to him? It's just that I saw these parts of him as an opposition to one another, and that's what made them seem so clear. There was one way of being an artist, and then another way of being an artist with a capital 'A.' There were all the things that took place at the level of his ordinary human praxis, and then there was a kind of Duchamp in battle dress with all of his particular positions to defend. And all I'm trying to talk about is the way the one with the capital 'A' was the idea of himself that he communicated to the world. And I'm also saying that the world took it in a little too thoroughly. The world took in his message without paying sufficient attention to the style of his delivery, and what we get now from the world is a picture that's a little excessive in its insistence on Duchamp as some kind of Samurai or Zen master who was always entirely above it all. That's even a part of what his friends most often have to say about him. In the preface to the *Notes*, Paul Matisse, who is his stepson, even remarks that he thinks of Marcel as a person who had resolved all of the ordinary problems of life at a time when he was still very young. But his friends don't always leave it at that, and some of them were sharp enough, and interested enough, to notice all sorts of

other things that don't quite fit in with that sort of picture. Cage talks about the way he was really very intrigued by money, or intrigued at least by the fact that he didn't know how to make it when he could see that people like Rauschenberg and Johns were pulling in hundreds of thousands of dollars at a time. Coply talks about his having had a very great need for something to do to fill up his time, and what could be less Olympian than a need to fill up your time? And there are all sorts of other contradictions that you can see as well. He felt he had to reject the idea of the museum, but in Philadelphia he practically has a museum all to himself. On the one hand he promulgates a refusal to have anything to do with painting and absolutely denies that there's any meaning in painting, but he was involved with the Société Anonyme where he was buying and selling paintings and writing essays about the painters. Money and the market were of no importance, but he made his living for a while by selling a bunch of Brancusis that he kept under his bed, and what's so fantastic about that when you get right down to it, why is it any less compromising to sell a Brancusi than to sell something of your own? And, in fact, his decision to give up painting didn't keep him from continuing to sell his earlier things for as long as he could; Arensberg wanted this, Arensberg wanted that, and Duchamp got on the boat and went to France and brought it back to him. Even later, when Mary Sisler got involved in collecting his work, he was always looking for this or for that, trying to recover something he'd given to a friend or a sister or a schoolmate half a century before. How does all of that fit into the myth? You have every right to ask that question and the answer is that it fits rather badly. And how do you deal with the multiples that he did of all the Ready-mades? That's not very Olympian either. All of

these things are the expression of the other part of him, the part of him that he wouldn't have confided to his official autobiography, or that he'd have relegated to a few footnotes in a rather fine print. They're the seams you see in the myth, they're the flecks of impurity in this crystalline object he really wanted to be. But they're also a part of him that's very much alive, and you have to deal with these things if you want to see how really great he was in spite of everything.

There's a very odd twist in all of this, because what, after all, are we interested in? We're not finally and fundamentally interested in the fact that he was really this very nice guy and that everybody loved him. And as to why he gave up painting, we wouldn't be happy with the ultimate explanation that he was really incredibly lazy and just didn't want the drudgery of sitting in a studio and turning out a canvas every day or every week or any other every how long it was economically necessary. That's not really the point at all. The point is that this larger human side of him contained the possibility of the other side of him; it was this larger human side of him that contained all the creative possibilities that he used, and he used them not only to create his works, but also for the creation of this other work that was his official myth of himself. The most important thing about this human Duchamp is that he understood the necessity for the other Duchamp, the Duchamp he programmed into existence, the Duchamp who became the myth Duchamp. What's important is this message he was always broadcasting: the message, or the vision, that it's possible to be a little different from the norm, it's possible to develop another way of thinking, it's possible to be involved with other and more basic kinds of

problems. You can create a work of art by creating an appointment with an object; you can talk about a nude of a woman as having an aspect that enters the fourth dimension, and then create a metaphor of that by doing it on a piece of glass; and then the glass breaks and you put it back together and then you do it all over again in terms of the most incredibly excessive notions of the most incredibly naturalistic realism, but you put it behind a door and have to look at it through a hole. That is all so incredibly bizarre. The whole constellation of all of these individual gestures he made is so incredibly bizarre. He was the first great master as an impresario of the bizarre, and the possibility he has given us is that we can be just as free-floating too, just as honest and just as inconsistent and with just as much license to do first one thing and then another in an entirely different, even an entirely contradictory direction. You take a bird's cage and go to a marble cutter and have him make imitation sugar cubes and then you put them all together with a squid bone back inside the cage and top it all off with a thermometer and a mirror on the bottom of it and you call it *Why Not Sneeze?* and sign it with a transexual pseudonymn. That's the way his whole life might be described, and you can't get a lot more bizarre than that. That's a hell of a lot better than ships and shoes and sealing wax and cabbages and kings because it doesn't even have rhyme or meter or even alliteration, the very least he could have done would have been to call it 'Cage' or maybe 'Sugar Bowl,' but he's just that perverse and lets the confusions snowball into something total, and you can never quite figure out why.

This image that he gives us of himself is really what we have to thank him for. And the fantastic thing is that all

the things that contradict it finally prove the strength of it, and we have to thank him for them too. We have to thank him for not having removed them by disappearing off into the heart of darkness like Rimbaud, and why is it, really, that he didn't? Why did he always remain connected to art? Why did he craft this message that was in any case destined to remain a part, say, of the sociology of art? It's as though he'd decided that that was where his function lay, and he's not likely, say, to be rediscovered as a fundamental myth for the world of chess players. He turned himself into a living lesson that existed in a very specific place; he turned himself, like we said before, into the principle officiant of a very particular temple. In terms of use value, he turns out to be his own greatest work of art, or at least that's what he has turned out to be so far—use value, I mean, in the sense of a work that gives inspiration for the production of other work; that, after all, is what art is all about, it's about the perpetuation of the impulse to art.

Another way of putting it would be to say that he presented himself with a manifesto of indifference that ends up by creating its opposite extreme, which is a sense of scandal. He was preaching indifference, and he in fact put that kind of indifference into practice, but the result he achieved, and perhaps intended to achieve, was for the people who received his message not to be indifferent at all. That, really, is the heart of the matter. His indifference becomes scandalous, and rather than indifferent we find ourselves tremendously intrigued. What he does is to catalyze you into accepting his challenge, and his lesson is always something you end up by inventing for yourself. He's just sort of there, always dressed in his habit as the

empêcheur, and somehow or another you anchor yourself into that; there's nowhere else to find an anchorage; of all the various possibilities, he's the most attractive, the most sympathetic, the most skeptical, the most available, and the one, too, who's fullest of contradictions. He's not, after all, Lenin holding a discourse from the roof of an armored truck and a constant, implacable enemy of the capitalist structure of the economy of the world; he's only an artist and he has the kinds of coherence, the kinds of consistency that you can expect from an artist, that you want to expect from an artist, and that's a consistency that's full of contradictions, a consistency where everything, finally, is possible.

So, when we look at the parts of Duchamp that don't quite fit the myth, what we end up with isn't demystification at all. We end up with the feeling of just how important this myth continues to be, and what doesn't fit into the myth is something to be content to note and then pass over. I wrote a piece called 'Duchamp from a Human Point of View' over ten years ago, and these things I'm saying now that seem like reservations are things I was already saying then. But the point of that is that these things come back to mind again and again because you forget them again and again; they're really just that unimportant. And you don't forget them once and for all, because that too would be unimportant. You remember them because you want to remember that they're forgettable. You look at the whole truth and what you see are the relative weights of the various parts of it. The thing about this myth is that it's something we choose to believe, and being able to make that choice is also a question of having to know that it doesn't come perfectly into line with real-

ity. In addition to being a myth, it's also an aspiration, or
the perception of a possible archetype. The very function
of the myth is to give body and expression to an aspiration,
and this aspiration is something you can assume when you
know precisely what you're doing. That's a part of the very
essence of being a modern kind of person: the faculty of
being able to make a choice about what it is that you want
to be. And I always have to remember that this myth is a
myth that belongs to me, which means that I have to be
very careful about projections of the myth for which
Duchamp himself isn't responsible. He had a certain tact
and humor about presenting himself as a Samurai since he
was a master of creating compatibilities between con-
tradictions, and I don't see that any of that tact and humor
is being respected when his attitude becomes the base for
some scholar's examination of the esoteric relationship
between Duchamp and the sources of Zen in pre-
Buddhistic Tibet. I want him all for myself, and if he's to
become an impulse in 'culture,' I'm the one who's going to
decide what sort of culture I want to breed myself in.

One thing I want to be able to do at the end of all of
this talking about Duchamp is to swear that I've not in any
way attempted to reduce him to a similarity with anything
else. And I've seen very clearly that I've not reduced him to
anything else in some of those moments, well, some of the
moments of profound disturbance we've felt while making
these tapes. It's that disturbance that people are trying to
avoid when they turn him into all of the various commen-
taries that they've tried to turn him into. These are
moments when it's as though the earth is dropping out
from beneath your feet, or as though a hand has taken you
by the back of the neck and you feel yourself go cold:
moments when you see absolute difference, absolute indi-

viduality, and when you can't explain how absolute indi-
vidualities can even touch each other. It gives you a kind
of vertigo, it excites you, it makes you angry, and it makes
you feel alive. That's what he's for.

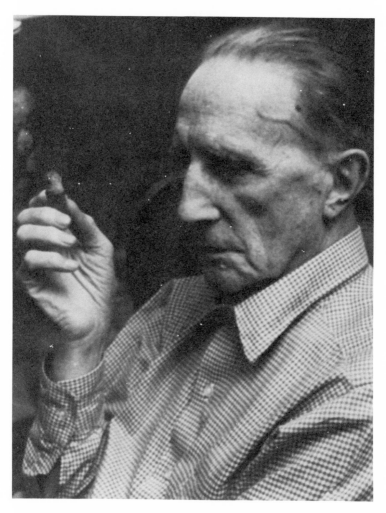

Marcel Duchamp, circa 1964. Photo: Baruchello.

SELECTED BIBLIOGRAPHY

The most comprehensive bibliographies on the work of Marcel Duchamp are to be found in *The Complete Works of Marcel Duchamp* by Arturo Schwarz; in *Marcel Duchamp* by Robert Lebel; in the catalogue of the Marcel Duchamp exhibition held jointly by New York City's Museum of Modern Art and the Philadelphia Museum of Art in 1973; and in the catalogue of the Marcel Duchamp retrospective at the Centre Georges Pompidou, in Paris, in 1980. Here, we intend simply to acknowledge the works we had occasion to consult in the course of the conversations from which this book developed. Marcel Duchamp's writings and interviews head the list, in chronological order. All other publications are presented alphabetically.

WRITINGS BY MARCEL DUCHAMP

Marchand du Sel. Ecrits de Marcel Duchamp, réunis et présentés par Michel Sanouillet. Paris, Le Terrain Vague, 1958.

The Bride Stripped Bare by Her Bachelors, Even. A typographical version by Richard Hamilton of Duchamp's "Green Box." Translated by George Heard Hamilton. London, Lund, Humphries; New York, Wittenborn, 1960.

Notes and Projects for the Large Glass. Selected, ordered, translated, and with an introduction by Arturo Schwarz. London, Thames and Hudson; New York, Abrams, 1969.

Marcel Duchamp, Notes. Presented and translated by Paul Matisse, and with an introduction by Pontus Hulten. Paris, Centre National d'Art et de Culture Georges Pompidou, 1980.

INTERVIEWS

Sweeney, James Johnson. "A Conversation with Marcel Duchamp." As presented in *Marchand du Sel*.

Cabanne, Pierre. *Entretiens avec Marcel Duchamp*. Paris, Pierre Belfond, 1967.

OTHER PUBLICATIONS

The Almost Complete Works of Marcel Duchamp. Catalogue, published by The Arts Council of Great Britain, for the exhibition held in London at the Tate Gallery from June 18 to July 31, 1966. Introduction and catalogue text by Richard Hamilton.

L'Arc (Aix-en-Provence), no. 59, 1974. Special issue dedicated to Marcel Duchamp.

The Arensberg Collection. Philadelphia, Philadelphia Art Museum. with an introduction by Henry Clifford. 1954.

Art and Artists (London), vol. 1, no. 4, July 1966. Special issue dedicated to Marcel Duchamp.

Boatto, Alberto. *Il segno —Introduzione a Marcel Duchamp, marchand du sel*. Naples, Rumma Editore, 1969.

Breton, André. "Marcel Duchamp, Phare de La Mariée." *Minotaure* (Paris), vol. 2, no. 6, Winter 1935.

By or of Marcel Duchamp or Rrose Sélavy. Catalogue of the Marcel Duchamp retrospective held at the Pasadena Art Museum from October 8 to November 3, 1963. Edited and with a catalogue text by Walter Hopps, and with a conversation between Marcel Duchamp and Richard Hamilton.

Cabanne, Pierre. *Les trois Duchamp: Jacques Villon, Raymond Duchamp-Villon, Marcel Duchamp*. Neuchatel, Joles et Calendy, 1975.

Calvesi, Maurizio. *Duchamp invisibile*. Rome, Officina Edizioni, 1975.

Clair, Jean. *Marcel Duchamp ou le grand Fictif*. Paris, Galilée, 1975.

_____. *Duchamp et la photographie*. Paris, Cheñe, 1977.

Dreier, Katherine S. and Matta Echaurren. *Duchamp's Glass: La Mariée mise à nu par ses célibataires, même. An Analytical Reflection*. New York, Société Anonyme, 1944.

Lebel, Robert. *Sur Marcel Duchamp*. Paris, Trianon, 1959.

Lyotard, Jean-François. *Les Transformateurs Duchamp*. Paris, Galilée, 1977.

Marcel Duchamp. Catalogue of the exhibition held jointly in New York and Philadelphia at the Museum of Modern Art and the Philadelphia Art Museum in 1973. Edited by Anne d'Harnoncourt and Kynaston McShine.

Marcel Duchamp. Catalogue in four volumes of the exhibition held in Paris at the Centre National d'Art et de Culture Georges Pompidou in 1980. Vol. I: *Plan pour écrire une vie de Marcel Duchamp*, par Jennifer Gough-Cooper et Jacques Caumont. Vol. II: *Catalogue raisonné*, redigé par Jean Clair. Vol. III: *Marcel Duchamp. Abécédaire*. Approches critiques sous la direction de Jean Clair avec la collaboration de Ulf Linde, Olivier Macha, Véronique Legrand et Jeanne Bouniort. Vol. IV: *VICTOR (Marcel Duchamp)*, roman par Henry-Pierre Roché, texte établi par Danielle Régnier-Bohler, preface et notes par Jean Clair.

Mashek, Joseph. *Duchamp in Perspective*. Englewood, Spectrum, 1975.

Not Seen and/or Less Seen of/by Marcel Duchamp/Rrose Sélavy 1904-1964: The Mary Sisler Collection. Catalogue of the exhibition of the Mary Sisler Collection held in New York at the Cordier and Ekstrom Gallery from January 14 to February 13, 1963. Foreword and catalogue texts by Richard Hamilton.

Oliva, Achille Bonito. *La delicata schacchiera: Marcel Duchamp 1902/1968*. Florence, Centro D, 1973.

_____. *Vita di Marcel Duchamp*. Rome, Marani Editore, 1976.

Paz, Octavio. *Marcel Duchamp. L'apparence mise a nu*. Paris, Gallimard, 1977.

Sanouillet, Michel et Peterson, Elmer. *Marcel Duchamp. DUCHAMP DU SIGNE*. Paris, Flammarion, 1975.

Schwarz, Arturo. *Marcel Duchamp. Ready-mades, etc. (1913-1964)*. With an introduction by Walter Hopps and a chapter by Ulf Linde. Milan, Galleria Schwarz; Paris, Le Terrain Vague, 1964.

_____. "Duchamp's Young Man and Girl in Spring." *American Imago* (New York), vol. 25, no. 4, Winter 1968.

_____. *The Complete Works of Marcel Duchamp*. New York, Abrams; London, Thames and Hudson, 1969.

_____. *Marcel Duchamp. 66 Creative Years ("From the first painting to the last drawing")*. Catalogue of the exhibition held in Milan at Galleria Schwarz from Dec. 12, 1972 to Feb. 28, 1973.

_____. *Marcel Duchamp*. Milan, Sansoni Editore, 1974. In the series *I maestri del novecento*.

Su Marcel Duchamp. Raccolta di scritti di M. Calvesi, A. Izzo, F. Menna, A. B. Oliva, T. Trini, A. Schwarz. Naples, Edizioni Framart, 1975.

Surrealism and its Affinities: the Mary Reynolds Collection. With an introduction by Marcel Duchamp. Chicago, The Art Institute of Chicago, 1956.

Tomkins, Calvin. *The World of Marcel Duchamp 1887-*. New York, Time Incorporated, 1966.

Vaccari, Franco. *Duchamp e l'occultamento del lavoro*. Modena, privately printed, 1978.

La vie illustré de Marcel Duchamp, par Jennifer Gough-Cooper et Jacques Caumont, avec 12 demis d'André Raffray. Paris, Centre National d'Art et de Culture Georges Pompidou, 1977.

View (New York), ser. 5, no. 1, March 1945. Special issue dedicated to Marcel Duchamp.

DATE DUE